Images in Light: Stained Glass 1200–1550

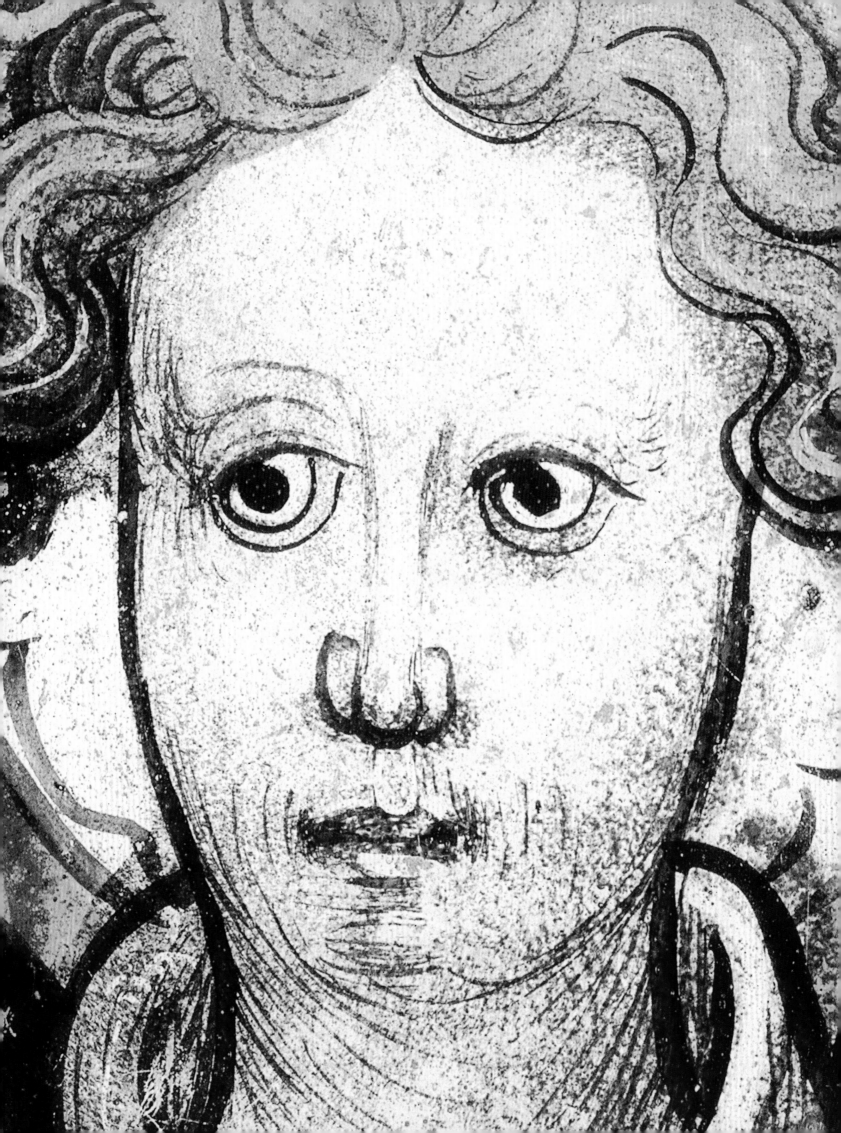

Michael Michael

Images in Light: Stained Glass 1200–1550

Sam Fogg, London, 2002

Sam Fogg
15d Clifford Street
London W1S 4JZ

TEL 020 7534 2100
FAX 020 7534 2122
E-MAIL info@samfogg.com
WEBSITE www.samfogg.com

Catalogue 26

Research and editing by David Hosking

*We would particularly like to thank
the following for their help in preparing
this catalogue:*

Tim Ayers
Jane Bridgeman
Neil Phillips
Victor de Baux
Christine Davis
Daniel Hess
Ivo Rauch
George Wigley
Keith Barley
Barbara Giesicke
David Ekserdjian
Andrew Morall
Virginia Raguin
Jim Marrow
Norbert Jopeck
Hartmut Scholz
Madeleine Blondel
Elisabeth Taburet-Delahaye

DESIGN Mark Vernon-Jones
PHOTOGRAPHY Matt Pia
PRODUCTION Robert Marcuson

Printed in the UK
ISBN 0-9539422-3-6
© 2002 Sam Fogg, London

FRONT COVER
Head of Christ, detail from *The
Crucifixion with St Christopher* (no. 28)

BACK COVER
Detail from *St George with the Arms of
Speth* (no. 40)

Frontispiece:
Head of an Angel,
detail from no. 14.

Contents

INTRODUCTION

A Technological Breakthrough

Stained glass was completely unknown in antiquity. That it became a vehicle for figurative pictorial communication in the Middle Ages is one of the most significant steps in the artistic heritage of Europe. In terms of its technical innovation and cultural significance it can only be compared with the invention of the television screen. Where lantern slides and cinematic images use the process of shining light through an essentially transparent layer, which is projected on to a surface and then reflected back to an audience, the television, or monitor, generates its own light through electricity. Stained glass is powered by the light of the sun in the same way. When glass is used in church and municipal settings the person or group that has control over the choice of images also has an opportunity to communicate through a medium that enforces itself upon a large audience. When pictorial glass became used in a domestic setting in the later Middle Ages, it also took on a role similar to that of a transmitted image – it was brought into the home, when once such images were seen as part of a communal space. Stained glass does not rely on narrative storytelling and the sending of symbolic messages alone. The varying degrees of brightness and opacity that different strengths of sunlight can have on stained glass at morning, noon and evening allow the glass to generate changes that affect mood and that create movement and shifts of colour in an otherwise stationary image.

Like all forms of art, stained glass was never entirely the product of practical considerations. It is part of its nature that it can serve many different functions, from the religious and didactic to the commemorative and the political. The writers who interested themselves in stained glass in the Middle Ages were mostly concerned with the spiritual importance of light and its symbolism as a vehicle for ethical and moral statements about the nature of God. This has led to the misapprehension that stained glass is an essentially religious medium of expression. It can be argued, however, that these writers were only aiming at a

Opposite: detail from *Eberler Arms* (no.21)

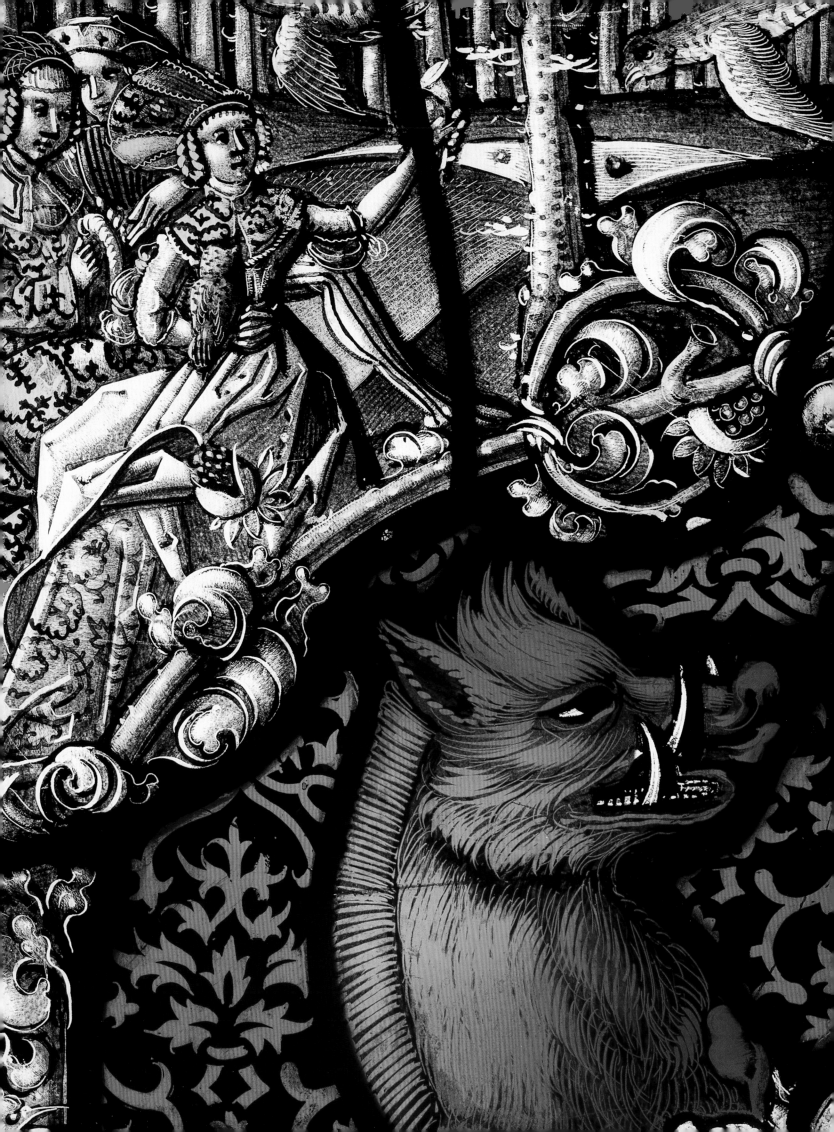

tiny proportion of the large numbers of people who experienced stained glass in its public settings. As with all European art, the development of stained glass has been driven by a range of religious, social, political and economic forces, with those in positions of power and influence being keen to use innovative and efficient modes of expression.

TECHNIQUE AND INNOVATION

As with all artistic media, the techniques used in stained-glass making have undergone a number of changes over time. What was called pot-metal glass dominates the Romanesque and early Gothic periods. This is glass that is coloured through and through by the addition of various metallic oxides put into the pot of molten glass. With red, the glass was made thinner and melded with sheets of clear glass to give it greater light-transmitting qualities. This so-called 'flashed' glass was often deliberately abraded to give the impression of white on the same piece. All the other individual colours had to be separately leaded. One of the most difficult processes was to produce paint that could be fired and adhere to the glass: the mixture was nearly always a thick black or brown India ink made of various oxides ground in with glass and binders. It was not until the later fifteenth century that enamels were developed. The unity of purpose and clear lines that well-preserved early glass shows is born of the choices made by the designer and glazier when confronting these practical problems.

One of the key technical innovations affecting artistic choice was the discovery of the formula to produce a golden translucent yellow stain on clear glass without the necessity for a leaded break. The potential for silver nitrate to stain clear glass yellow was known in Byzantium and in the Arab world and may have passed into Europe via Spain; it is referred to in the *Lapidario* of Alphonso the Wise of Castile (1221–84). The earliest datable example is in the Peter de Dene Window at York Minster (c. 1307–10), but the technique

was known throughout Europe by the early fourteenth century. This use of silver stain revolutionized glass painting in the fourteenth century. Hair, in particular, could now be painted on the same sheet as the face and could conform to the ideal of blond beauty (especially for images of the Virgin) which was already popular. Decisions governing the amount of light to be allowed into a building were never really affected by these technical considerations, but the technique of silver stain arrives at just the moment when architects wanted to create greater openness and brightness. It was also realized quite early on in the history of silver staining that by abrading pot-metal flashed glass down to the clear layer and then adding silver stain in the gaps, red and yellow could appear together. Silver stain could also be used to add a layer to flashed light blue glass in order to create a green by allowing the light to mix the two colours.

PATRONAGE, AUDIENCE AND RECEPTION

The theological priorities of the patrons of the Rose Window at Reims and the narrative windows at Rouen in the thirteenth century are clear: large symbolic hierarchies and didactic series of windows dominate the glazing programmes [1, 2]. These are not the priorities of the secular patrons who endowed small parish churches, nor are they those of the rich bourgeoisie that commissioned many of the armorial panels of the late fifteenth the sixteenth centuries. The classic pattern for the development of society in the Middle Ages and the Renaissance suggests a movement from patronage in the service of God to patronage governed by princely and noble families, who are then imitated by the new bourgeoisie. Such an interpretative structure, however, can run the risk of ignoring the often subversive intervention of the individual artists who produced and designed the glass, and of those for whom it was made. Patrons were aware of the different types of audience that might come into contact with their

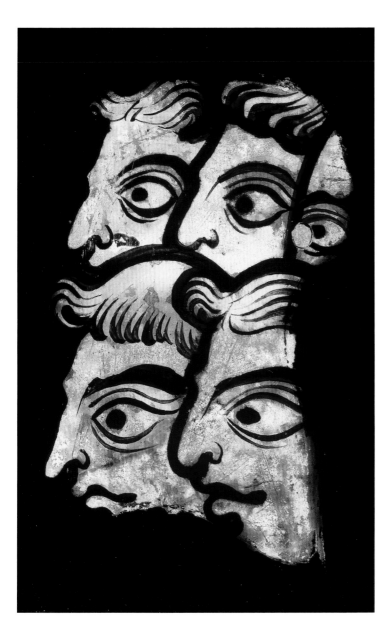

Onlookers, detail from *Composite Roundel* (no. 1)

projects. The patron of the Klosterneuburg Master [6] understood that he was in a place where tradition mattered. The great achievements of the twelfth century were all around him, including the great Ambo of Nicholas of Verdun of c. 1181, transformed into an altarpiece in 1333. He also knew that the glass was going to be experienced by an audience perhaps more educated in the niceties of historical and iconographical references than would normally be the case. At the small parish church of Meysey Hampton in Gloucestershire, by contrast, the characterization of the faces and the immediacy of the gestures adds a searing realism to figures that once graced the Crucifixion scene [4,5]. The quality of the drawing and the vibrancy of the colour suggest that a vivid aesthetic experience was intended – one that would communicate clearly with its audience. This is not glass that represents 'popular culture', in ny modern sense of the term, but what it does represent is art created by craftsmen who belonged to a unified culture that demanded the best art in the most innovative and important of public media (stained glass). This emphasis on quality and modernity – in a sense, an interest in the avant-garde – is seen over and over again, especially in the glass that comes from French parish churches, which often rivals that of the French cathedrals.

The changes in stained glass that occur in the fifteenth and sixteenth centuries again depend on shifts in the social and economic structure of society. Any technical innovations that arise serve to enhance these changes and allow their further expression. The seamless join in people's minds between religious imagery and the family home is typical of this period. The intimacy of Hans Memling's *Diptych of Maarten van Nieuwenhove*, a captain of the civil guard, councillor and municipal treasurer of Bruges, epitomizes the domestic context that should be imagined for stained glass in the fifteenth century. St Martin, the sitter's patron saint, is depicted on the right, and the popular Sts

George and Christopher are placed on the left-hand side in silver-stained roundels. Both are in the upper part of a casement, which would only close when the wooden shutters were pulled over. It is notable that the family arms and motto are presented as a full achievement between stained glass roundels of a garden (a punning reference to his name, which means 'new garden'). The popularity of armorial glass sees court artists, such as the Housebook Master [21], engaged in the production of designs that could be adapted by different glassmakers for the newly rich bourgeoisie.

By the sixteenth century, roundels (and small panels) could be bought by anyone with a modest income. They appear to have had a commemorative function and were bought for events such as marriage, which indicates that they were probably valued as heirlooms, like modern-day wedding gifts. The obvious popularization and secularization of these pieces, seen in the emphasis on landscape settings and incidental detail, should not detract from our understanding of them as aides to devotion in many cases. Roundels such as that of the *Arrest of Christ* [34] were designed to focus attention on a particular moment in Christ's Passion and cause feelings of sorrow in the viewer that would result in fervent tears of sympathy as they prayed. Such roundels may have come from private rooms or chapels and cloisters, and their survival, often as part of English parish church furnishings, is a consequence of their popularity amongst English collectors from the time of Horace Walpole.

A MODERN MEDIUM

Drawings and prints become more and more important to the transmission of ideas in the later fifteenth century. The roundels associated with the style of Hugo van der Goes of Ghent were all probably made after his death in 1482, and depend on drawings after his work [22, 26]. Roundels in the style of artists working in Bruges, such as Hans Memling and Gerard David, may have also been

made from contemporary designs by these artists, but no prints survive. The work of artists such as Mantegna, Dürer and Raphael (through Marcantonio Raimondi's prints) becomes very well known in the early sixteenth century, and references to their compositions abound in glass. The new generation of artists, including Hans Holbein the Younger and Urs Graf, was well aware of the potential of printmaking and produced engravings that were widely disseminated and acted as sources for a whole generation of artists.

Stained glass was a mode of artistic expression that the very wealthiest magnates of the Renaissance believed could enhance their status. Nowhere is this better seen than in Giovanni Tornabuoni's insertion of a stipulation in his will for stained glass to be included in his chapel. Artists such as Ghirlandaio, whose workshop made the designs for the chapel, were often called upon to design stained glass, even if they did not execute it themselves. The panel attributed here to Ghirlandaio and his workshop suggests that patrons were aware of the subtle differences between the execution of different parts of even a single light, and they would have appreciated the intervention of the master himself in a panel such as this [27]. Identifying individual hands in stained glass is notoriously difficult, but in the case of the Stift von Bercheim panel [42] the collaboration of Urs Graf and Holbein can be suggested with some confidence. Graf was trained as a goldsmith, engraver and stained-glass painter. He appears to have been working with Holbein, who designed the overall scheme and no doubt provided drawings. This collaboration epitomizes a particular moment in the history of stained glass, when the greatest artists of the time were engaged in perhaps the most difficult painting medium, with the most extraordinary results.

It is difficult to underestimate the value that glass had to patrons in the early sixteenth century. It was their chosen medium of artistic

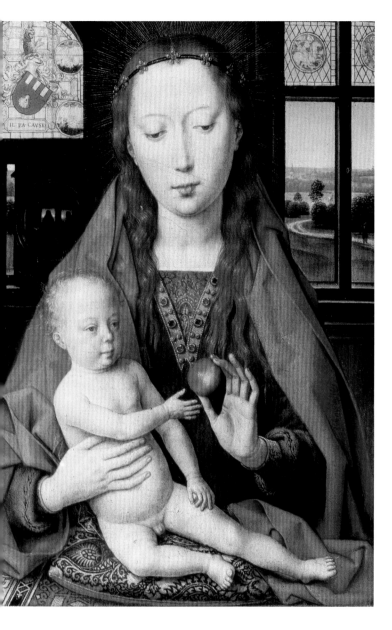

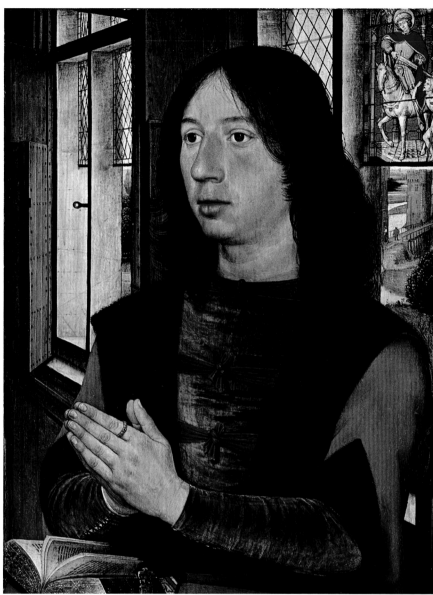

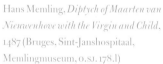

expression in public and private settings because of its modernity. The mythology that has grown up around stained glass in our own culture, which suggests that it should be regarded as a medium of medieval piety, has perhaps led to an underestimation of sixteenth-century glass in favour of earlier periods. The importance of the medium and the high regard and even affection in which it was held is symbolized by the survival of the head of an angel from Fairford Parish Church [37]. All the windows of this jewel of English art survive with glass of the highest quality – despite the Reformation and deliberate attempts to destroy it on numerous occasions by people who came with writs that bore the power of law.

Composite Roundel

Normandy, Rouen Cathedral?
c. 1210–20 with 14th-century and
later insertions

1 This panel retains a group of
highly expressive heads and
fragments of drapery which are
closely related to a series of panels
originally designed for the nave
of Rouen Cathedral after the fire
of 1200. These windows were
removed and re-set when side
chapels were created after 1270.
As Lafond pointed out in his study
of the Seven Sleepers Window
they were referred to for their
antiquity and beauty as *belles
verrières* by an early fourteenth-

century source, indicating the high
regard in which they were held
a century after they were made.
At least five panels relating to the
legend of the Seven Sleepers of
Ephesus were removed by 1911
and are now in North American
collections (Worcester,
Massachusetts, Worcester Art
Museum, 1921-60; The Raymond
Pitcairn Collection, The Glencairn
Museum (three panels); and New
York, Metropolitan Museum of
Art, Cloisters Collection,
1980.263.4). The drapery is a
highly accomplished form of the
muldenfaltenstil (or troughed-fold
style) associated with the Mosan
metalworker Nicolas of Verdun
whose ambo for the Abbey of
Klosterneuburg near Vienna of
1181 appears to be the earliest dated
source for its use. Its sculptural
qualities reflect antique prototypes
and even the damp fold of the
Parthenon frieze. This drapery
style permeated Western European
art c. 1200 to such an extent that
it can be seen in illuminated
manuscripts, wall and panel
painting, stained glass and
sculpture. Louis Grodecki has
suggested that the master of the
St John the Baptist window at

Rouen also executed the Seven
Sleepers panels now in North
American collections, and it seems
that this fragment should be
related to this artist. The intense
gaze of the eyes and the precise
execution of the noses and hair
may be compared with similar
glass at Laon, and the background
to this style in glass may be found
in the typological windows at
Canterbury of c. 1180. It is not
possible to identify any specific
scene in this glass, but if it were
from the *belles verrières* series of
Rouen Cathedral this would fit in
with Cothern's suggestion that
much of the glass had been
alienated before Lafond's
inspection of 1931.

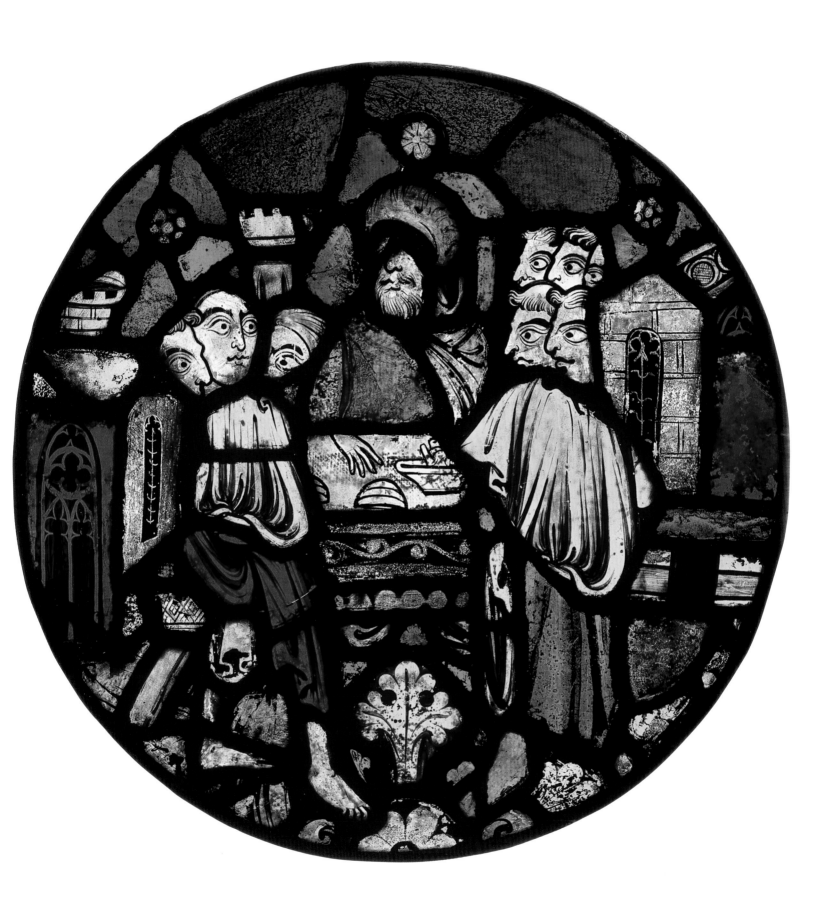

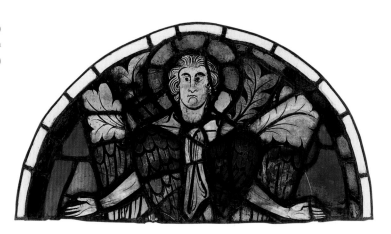

Seraph, c. 1275–99
(Ann Arbor, University of Michigan
Museum of Art, 1979/1.161)

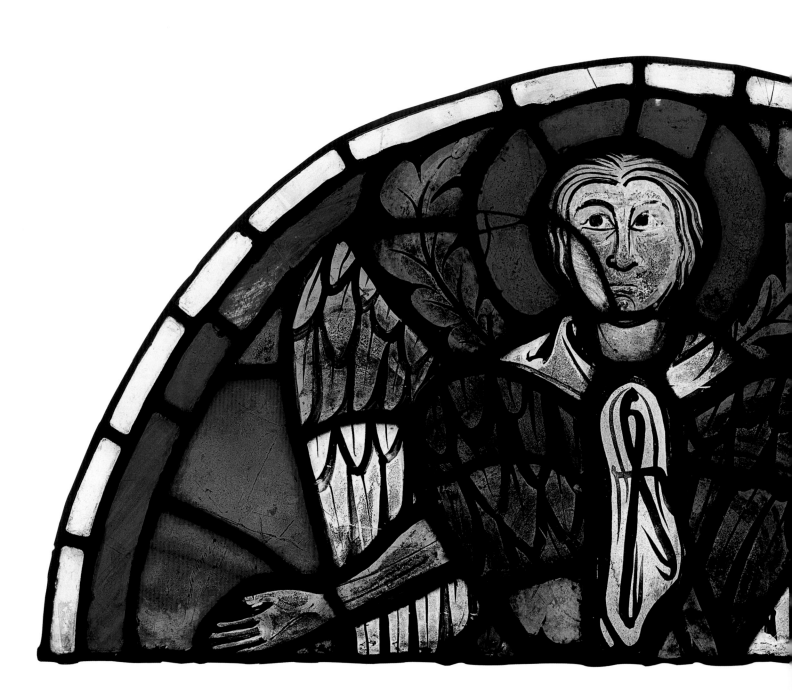

Seraph

*France, Reims
Cathedral of Notre-Dame
West Rose
c. 1275–99*

2 The fortuitous survival of this arresting panel is almost miraculous considering the disasters that befell Reims Cathedral between 1886, when a storm damaged the glass of the West Rose window, and 1914, when it was firebombed during World War I. It survives because it was probably removed between 1906 and 1909 by the French stained glass restorer Paul Simon. Another seraph from the same series (now at Ann Arbor, University of Michigan Museum of Art, no. 1979/1.161) has been assigned a date no earlier than 1280 on the basis that the upper parts of the cathedral were not finished before this time and on comparisons with Paul Simon's drawings of other lost seraphim. But the distinctive large eyes and wide faces, combined with the troughed folds of the drapery, suggest an earlier date, and more work on the chronology of the Reims West Rose may be required. Seraphim are the first of the nine orders of angels who stand in adoration around the throne of God singing the Trisagion, or Sanctus, which became associated with the preface to the Mass. They bear six wings; the lunette (originally in the form of a roundel) would have displayed the two missing wings below.

Head of a Young Man

France/Belgium,
Cambrai-Tournai?
c. 1320–30

3 This beautifully drawn head was probably made in the region of Cambrai in the early fourteenth century. Close comparisons may be made with the classic features and poise found in the work attributed to Maître Henri by Alison Stones in her recent publication of *Le Livre d'images de Madame Marie* (Paris, Bibliothèque Nationale, Nouvelles acquisitions françaises 16251). This illuminated manuscript is the most important of a group of books associated with the diocese of Cambrai c. 1300. Particularly close to the present work is the purposeful gaze of St John seen on folio 48: the angle of the head, the drawing of the hair and the wide forehead all suggest a common source. The strength of the jawline and the balance of the head, which suggest depth through careful drawing, are also characteristic of panel painting from Cologne in the early fourteenth century. Indeed, it is easier to find comparisons in German glass of the 1320s than in French glass (e.g. the Frauenkirche at Esslingen am Neckar), but this may be a reflection of the importance of painting from the Cambrai-Tournai region as a source for artists all over northern Europe at this time.

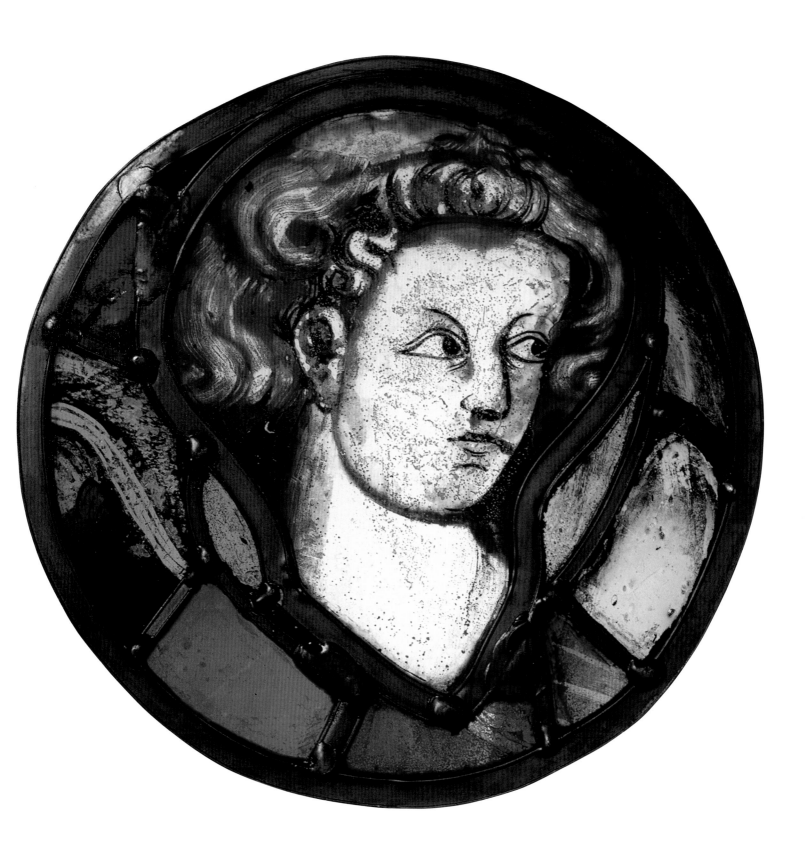

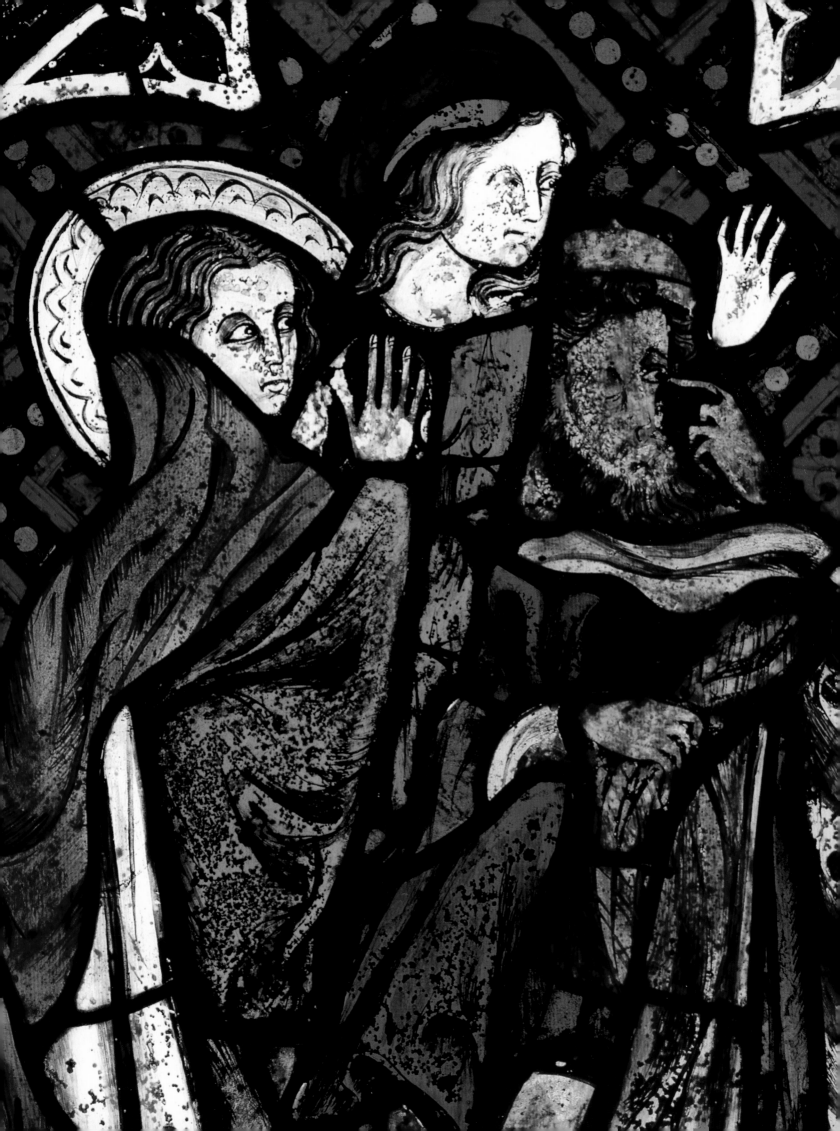

Three Figures from the
Crucifixion

The Crucified Christ

*England, St Mary's Meysey
Hampton (Gloucestershire)
c. 1330–40*

4 & 5 Despite the fragmentary nature
of these pieces, they are both
historically and artistically of the
highest importance. They are rare
and tantalizing survivals from one
of the greatest periods in the

history of English painting. The
ghost of a blue-robed Virgin lies at
the heart of this piece; behind her
the two expressive and beautifully
drawn heads of Mary the wife of
Cleophas and Mary Magdalene
(John 19:25), although they may
not be exactly *in situ*, must always
have formed part of the scene.
The head of Longinus,
traditionally the centurion who
pierced Christ's side with a spear,
has been inserted; he is shown
pointing at his eye to suggest a
miracle has occurred. The head
was not originally in this position
on the panel, but it certainly would
have been part of the original
composition, as the legend that
Longinus was blinded and cured
at the Crucifixion (or later at the
Resurrection) was particularly
popular in England in the late
thirteenth and early fourteenth
centuries. Stylistically the glass
is close to work at Eaton Bishop

Detail of *Sts Helena and Mary Magdalene*
from *The Butler Hours*, c. 1330
(Walters Art Gallery, MS W.105, f.12)

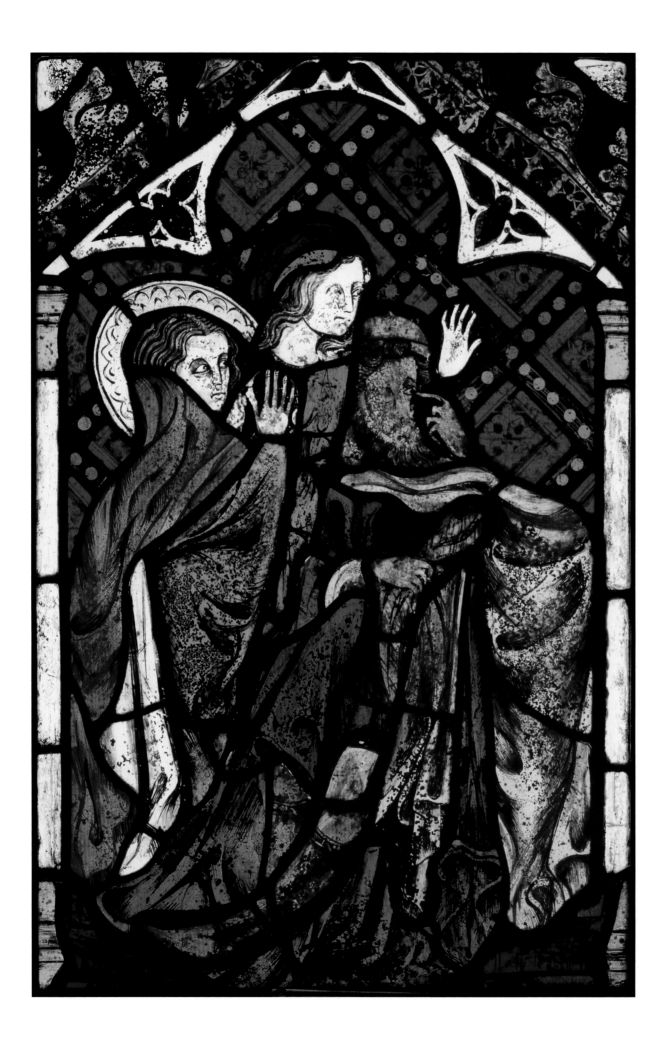

psychological expression is felt through the gaze of the eyes and the crisp drawing of the hair. The female heads are also close to work in illuminated manuscripts of the 1330–50 period. The drawing of the facial features and hair in the Mary Magdalene depicted in the *Butler Hours* (Baltimore, Walters Art Gallery, MS W.105, and Stockholm, Nationalmuseum MS B 1726-1727; see illustration) are almost interchangeable with those in the glass. The church of Meysey Hampton was greatly embellished in the early fourteenth century with the same ogival style as that seen in the surviving canopy work over the crucified Christ. Comparison between the window openings and the surviving glass in the church suggests that these panels almost certainly came from this church. Although it has been suggested that the church was refitted c. 1310, it is likely that the

glass is not much earlier than 1330–40 and that it is more in keeping with developments in English painting of c. 1340. The glass at Meysey Hampton was restored and replaced by N.H.J. Westlake in 1883, and further windows were added by Clayton and Bell in 1872.

4 & 5 continued

(Hereford and Worcester), but it appears to be by the same hand as the Annunciation group now in the Latin Chapel of St Frideswide's Cathedral, Oxford of c. 1340–50, where the same depth of

The Virgin and Child

Austria, Cistercian Abbey
of Klosterneuburg
Master of Klosterneuburg
c. 1335

6 This panel is by the early fourteenth-century Master of Klosterneuburg, who was responsible for the glazing of the cloister of the Cistercian Abbey c. 1335. His hand has also been identified in the Capella Speciosa in the Royal Palace at Vienna.

Klosterneuberg Master, detail of
The Birth of Isaac, c. 1330–35
(Leopold Chapel, Klosterneuberg Abbey)

Comparison between the *Virgin and Child* panel and the *Birth of Isaac* in the Leopoldskapelle at Klosterneuburg (see illustration) shows the same assurance of drawing and compactness of pose, combined with the distinctive sharp lime green balanced with ruby glass that only the Master's work possesses. It has been suggested that this panel originally came from the upper light of bay 2 of the cloister before it was removed. This probably occurred when the cloister glass was moved, finally arriving in the Leopold Chapel in 1836. The nineteenth-century inscription engraved in the Virgin's halo suggests that it was involved in a transaction in 1837. The Cistercian Abbey of Klosterneuburg, near Vienna, is one of the most important repositories of medieval art in Europe. The famous Klosterneuburg Ambo of Nicholas of Verdun (c. 1181) is just one of its treasures. The ambo was reworked into an altarpiece at exactly the same time as the glass in the cloister was commissioned – during the abbacy of Stephen von Sierndorf (1317–35) – and the typological iconography of

the glass owes much to this twelfth-century masterpiece. Retrospective portraits of the founding family of Babenberg were placed in positions of prayer in the tracery lights, and the Virgin and Child could well have been the intercessionary focus for their devotion. The iconography of this group is of particular interest as it is derived from the Byzantine Eleousa type. In the Byzantine examples the cheek of the child is usually held against that of the Virgin, but it is the secondary gesture of the child gently touching her chin that is emphasized here. The contemplative look of the Virgin and the assured gesture of Christ symbolize the Joy and Sorrow of the Virgin simultaneously.

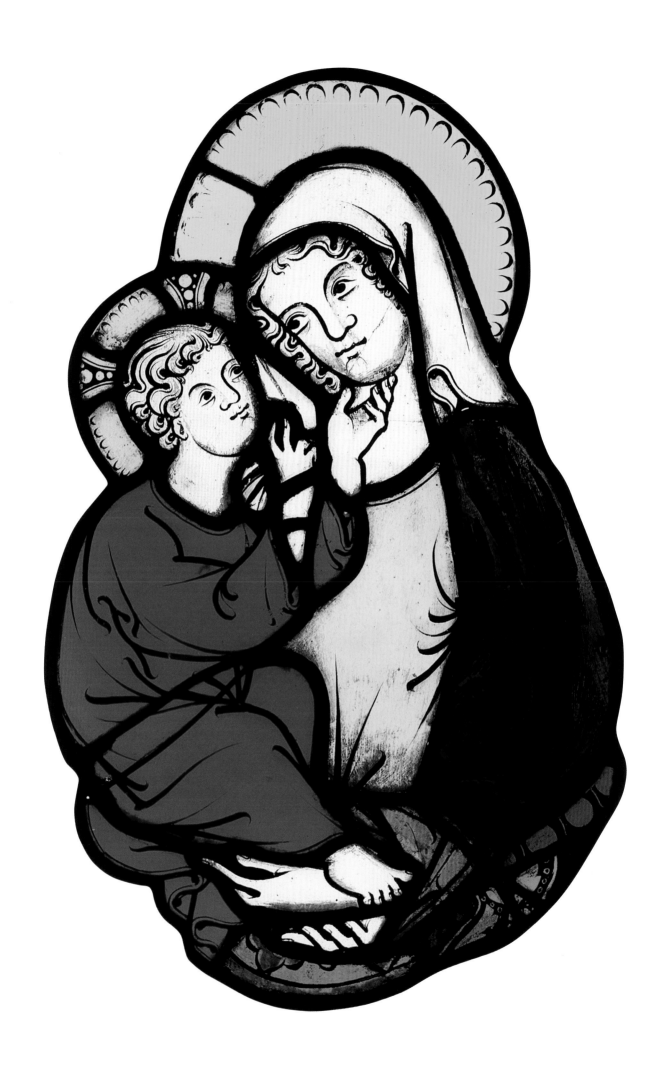

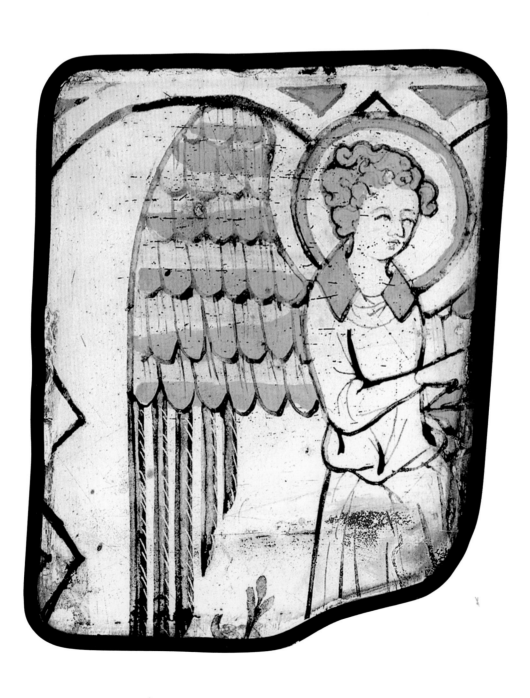

Stylistically close to a group of angels and clerics from the Pentecost window at Rouen Cathedral and which were in the collection of Jean Lafond (now Musée du Louvre OA 11250-52), these angels probably formed part of a border which was designed to let in a high percentage of light. Deliberately executed in grisaille with yellow embellishments, they epitomize the freedom that the silver-staining technique allowed the glass painter on a single sheet of clear glass. Before the introduction of the use of silver nitrate in a solution as a paint (which was applied on to clear glass and then re-fired, at which point it turned yellow) only the vitreous dark paint used for the drawing could affect the tone of the painting on glass. Stylistic similarities can also be found between these angels and the mid-fourteenth-century work at Saint-Ouen, Rouen, where many of these experiments with silver stain can be seen. Similar glass can be found throughout central, north and western France in the period c. 1340, such as the Mary Magdalene window at Mézières-en-Brenne (Indre). Glaziers following similar designs also worked at York Minster in England.

Two Music-Making Angels

France, Rouen Cathedral?

c. 1340–50

7

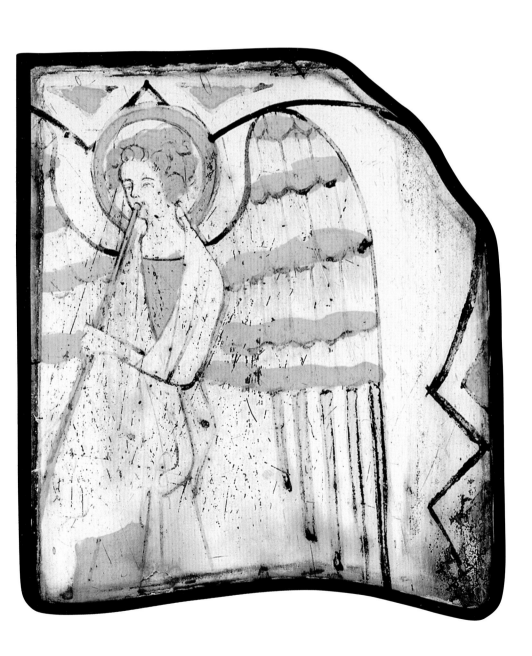

Head of an Angel or Saint

France, Bourges?

c. 1410

8 The head was probably made at the beginning of the fifteenth century. The tender drawing, the sweep of the nose and the treatment of the pupils may be compared with the highly innovative glass in the chapel founded by Pierre Trousseau, a canon of Bourges Cathedral. Particularly close is the figure of St William or St Ursin in the Virgin and Child group (bay 27, see illustration). Brigitte Kurmann-Schwarz has shown how this workshop used models, but these similarities alone do not confirm that the head comes from Bourges Cathedral. Similar glass can also be found in the chapel of Saint-Gilles at Evreux Cathedral. The importance of the ensemble also lies in the contribution of the restorer, who has given the piece something of the style of an art deco work by adding modern 'stiff leaf' oak leaves.

Head of a bishop saint, c. 1410 (bay 27, Chapel of Pierre Trousseau, Bourges Cathedral)

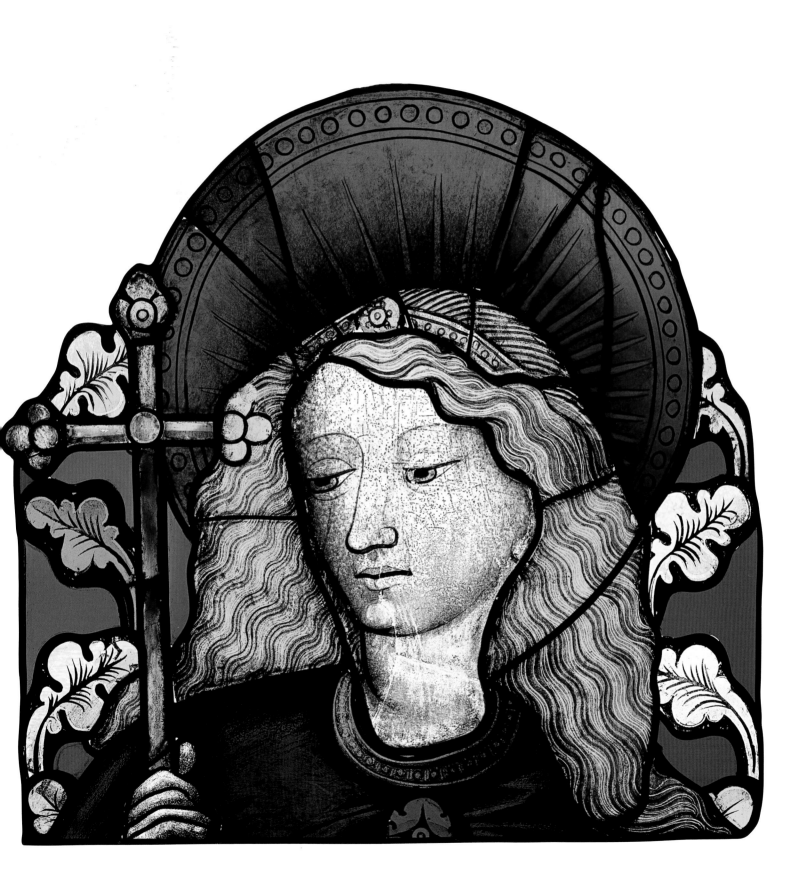

The Virgin and St John
from a Crucifixion

Germany, Erfurt?

c. 1420

9 These expressive and highly
emotionally charged heads once
flanked a larger than life-sized
image of the crucified Christ.
The drawing is simple in outline,
suggesting both grief and
resignation. Their monumental
scale indicates that they could
only have come from an important
series of glass in a very large
church, probably a cathedral.
The down-turned nose and eyes
are a characteristic of the Boniface
window at the Cathedral of Erfurt
of c. 1416. As Falko Bornschein has
shown, the restoration of the glass
at Erfurt took place between 1897
and 1911, and was most probably
carried out by the company of
R. and O. Linnemann c. 1910. This
suggests that the heads could have
been taken out of the cathedral at
this time. The damage caused by
pollution has rendered the glass at
Erfurt almost illegible – one must
assume that these panels have
survived in better condition
because of their removal. There is
also some comparison to be made
with the glazing campaign of the
1370s at Erfurt, but the two heads
look forward to the expressiveness
found in the later glass, perhaps
even being a precursor to the glass
at Boppard am Rhein of the 1440s.

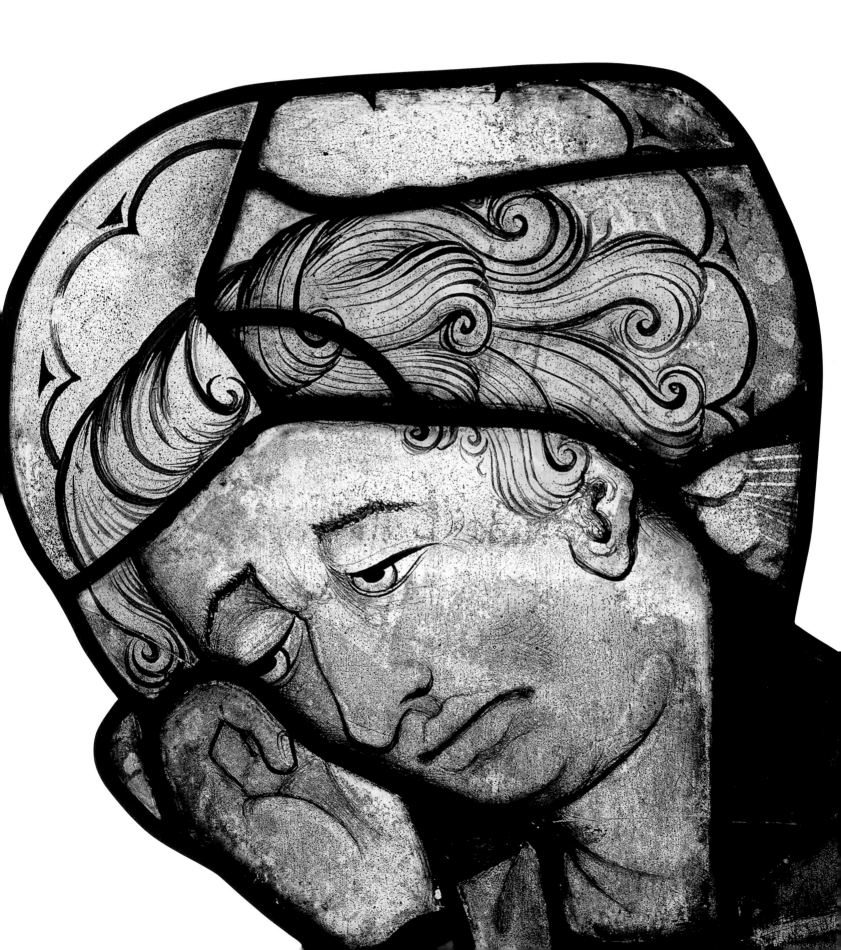

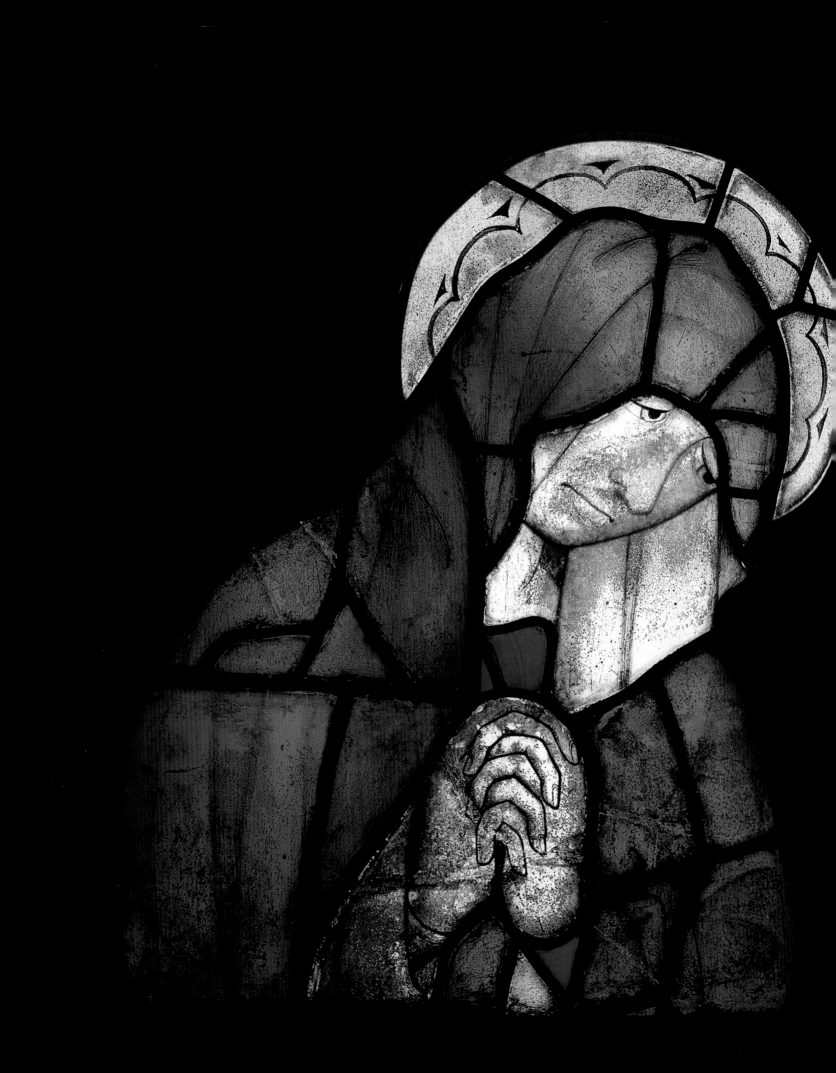

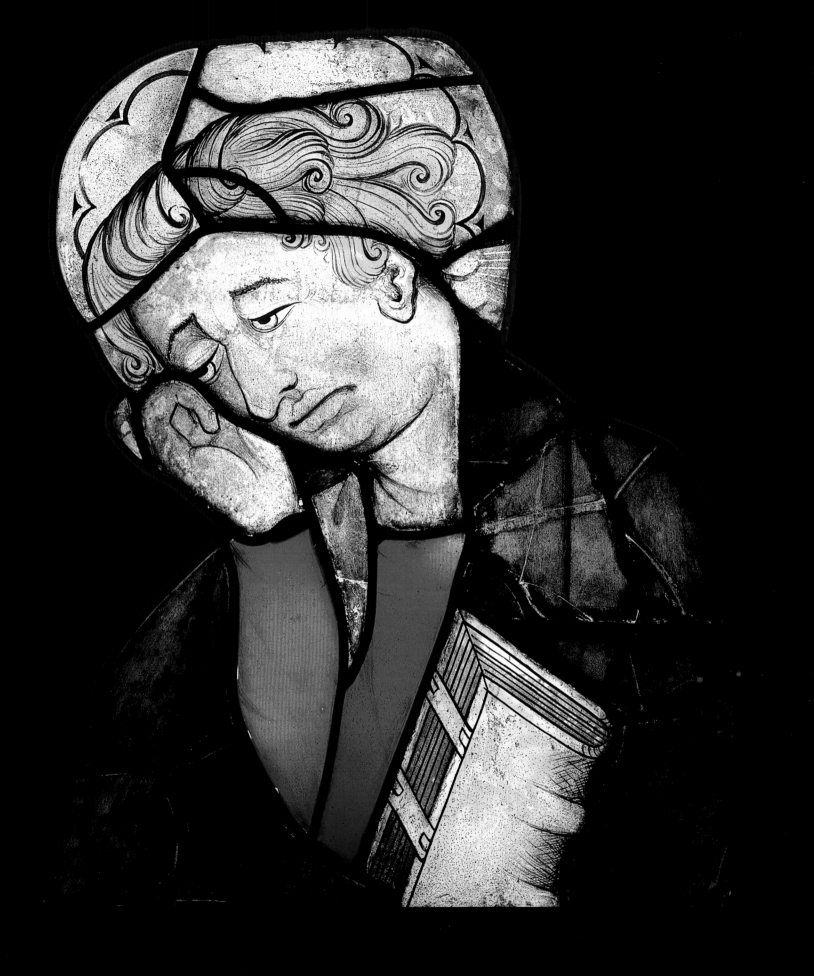

St Margaret

Germany, Cologne?
c. 1420–30

10 This beautiful panel has been associated with the so-called Gnadenstuhl workshop of stained glass painters at Cologne of the early fifteenth century. Dr Ulf-Dietrich Korn suggested at the Vor Stefan Lochner symposium that this panel of St Margaret should be dated around 1430, and that the figure could be compared with the *St Dorothy and St Odilia* in Münster by the painter Conrad von Soest, who worked in Dortmund. Brigitte Corley in her monograph on this highly influential Westphalian artist sees the glass as part of the broader acceptance of Conradian style in the 1430s, and also links it with the stained glass panel of the *Virgin and Child as the Woman clothed in the Sun* (New York, Metropolitan Museum of Art, gift of George D. Pratt, c. 1430–35*)*. The latter has also been linked with the *Gnadenstuhlfenster* in Cologne for iconographical reasons, suggesting that all of these panels were made there. It may also be compared with the glass from Partenheim (Rheinhessen), now in the Berlin Kunstgewerbe-museum, and it has also been associated (by Reisinger) with the glass of the Bessererkapelle in Ulm (c. 1430–31). Like the *Virgin and Child as the Woman Clothed in the Sun* in the Metropolitan Museum of Art, the St Margaret is a perfect expression of the delicacy and poise achieved by German artists in the first quarter of the fifteenth century. The softness and roundness of the facial features are given substance through the carefully constructed drapery and the perspectival niche in which the figure stands, blessing the donor's armorial. The glimpse of bluebells in the distance adds a charge of realism to the scene.

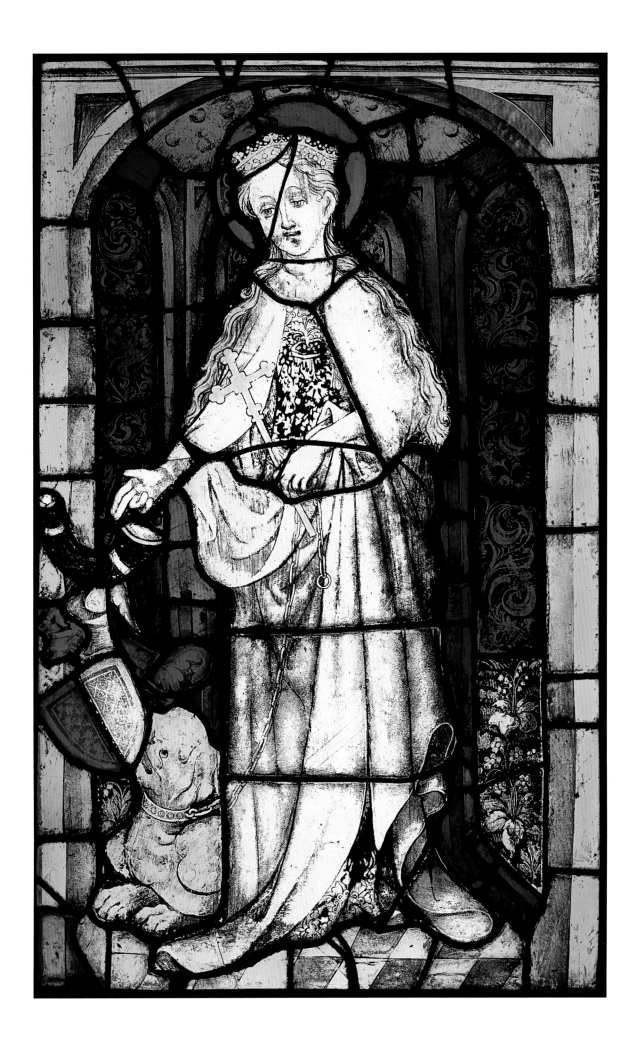

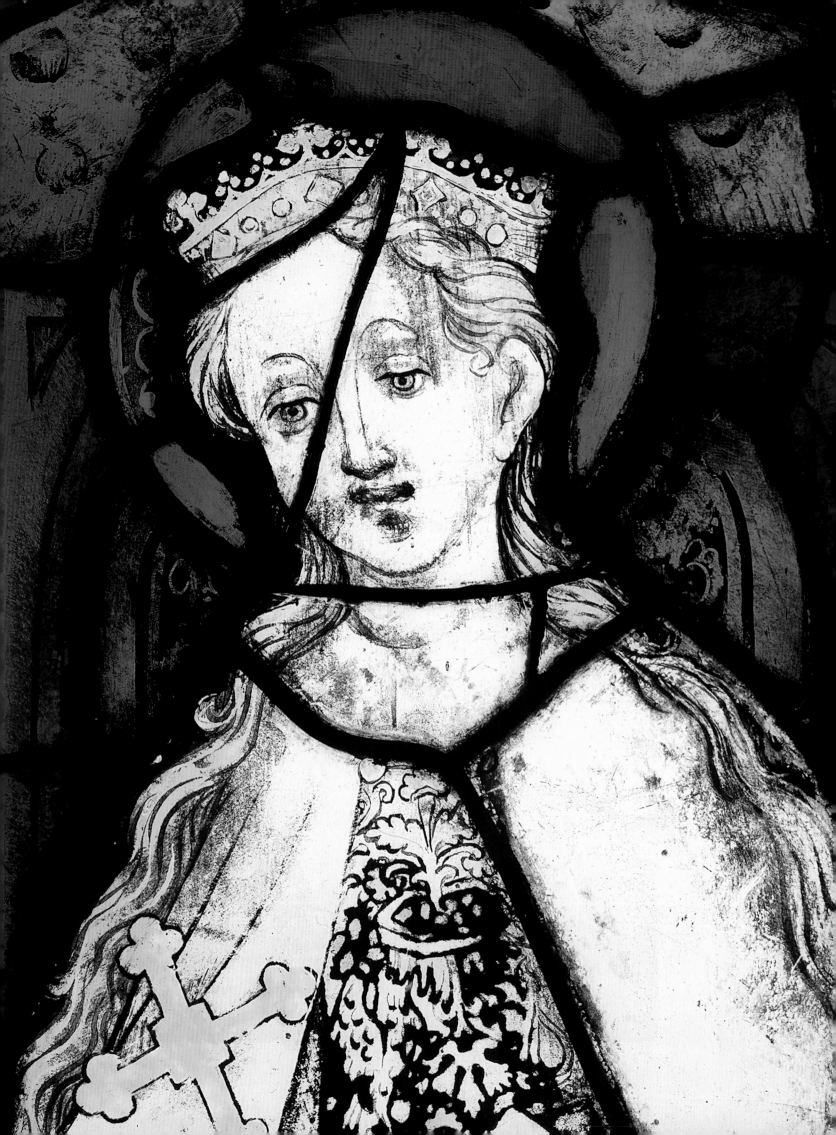

St John the Evangelist

Germany, Ulm?
c. 1430

11 The niche setting, angled
and viewed from below, is
characteristic of German glass
in the generation that followed the
work of Conrad von Soest of
Dortmund, who made so many
experiments in the shallow interior
setting of scenes in the first decade
of the fifteenth century (see no. 10
above). The scale of the figure here
recalls the Besserer Chapel in Ulm
(c. 1430–31), the stylistic sources
and development of which have
been studied by Reisinger.
Particularly close in scale and
setting is the panel of *God the
Father creating the Sun and Moon
and the Stars*. The softness of the
modelling and the confidence of
the setting also recall the
Gnadenstuhlfenster in Cologne
of the 1430s, but the flowing
sketchy painting of the head is
closer to that of the glass at Ulm.

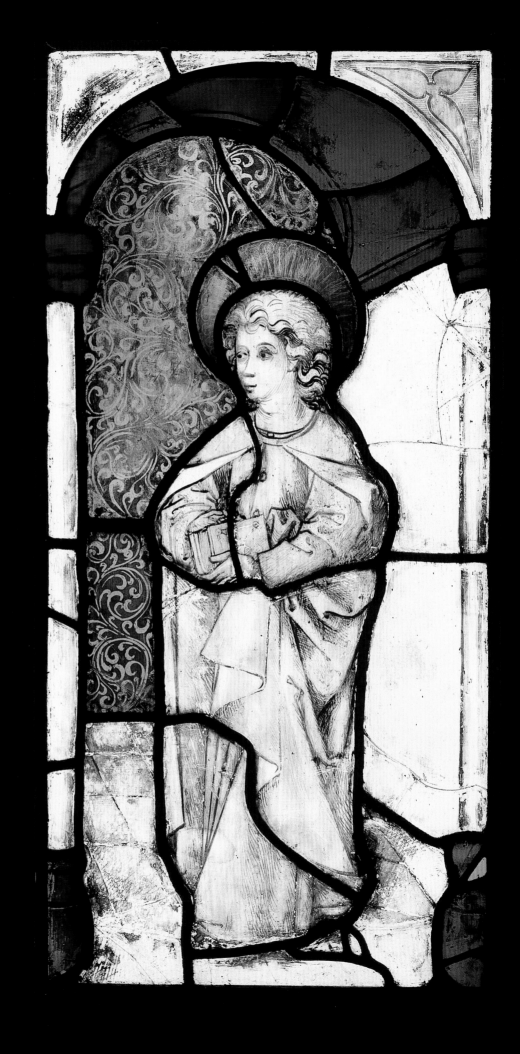

The Lion of St Mark

England
c. 1420–30

12 Zoomorphic evangelist symbols were extremely popular in stained glass in parish churches throughout England. This lion of St Mark shows a quality of drawing which should be compared with the work of John Thornton of Coventry in York after c. 1405. In particular, the emphasis on single curls in the hair – picked out both to form a silhouette above the hairline and within the hair itself – is a characteristic that this panel has in common with the *Angel Bidding St John to Write* from the great East Window (York Minster, I, panel 3d). The drawing of the eyes, with the emphasis on roundness and three-dimensionality, is also in keeping with later glass that seems to depend on Thornton's models in the Midlands, such as Hampton Court and even the East Window of Great Malvern Priory of c. 1423–39 (both Hereford and Worcester).

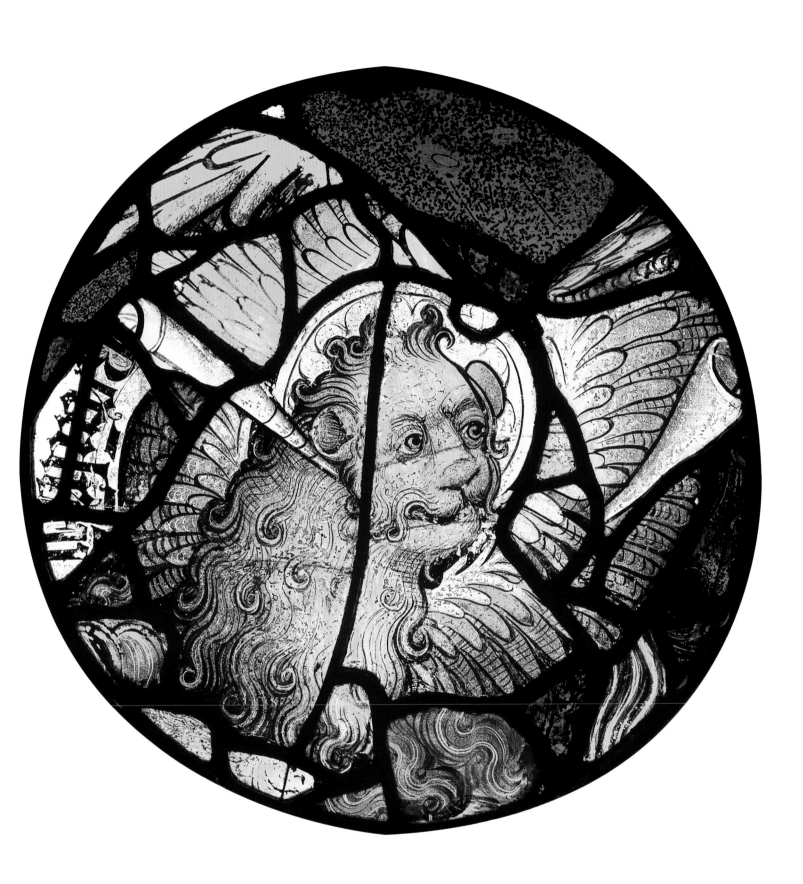

Two Angels

England, Midlands?
c. 1420–30

13 & 14 These two busts clearly
demonstrate the effect that John
Thornton of Coventry's work had
on English stained glass in the first
half of the fifteenth century. The
soft modelling, rounded eyes and
freely drawn hair are combined
with a confident application of
silver stain to achieve a balance
between clear and coloured glass.
The closest parallels are angels
from Chalgrove in Oxfordshire
(n.V), and St Michael's Church,
Coventry; however, comparisons
may also be made with glass made
between c. 1410 and c. 1440 in York
as well as in the Midlands.

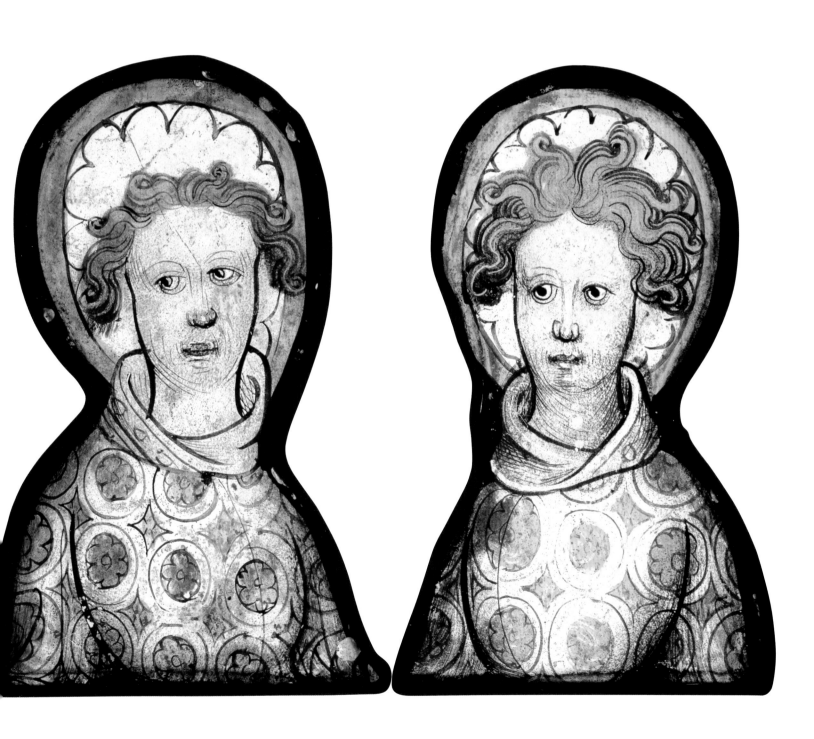

Kneeling Donor

France, Brittany
c. 1440–50

15

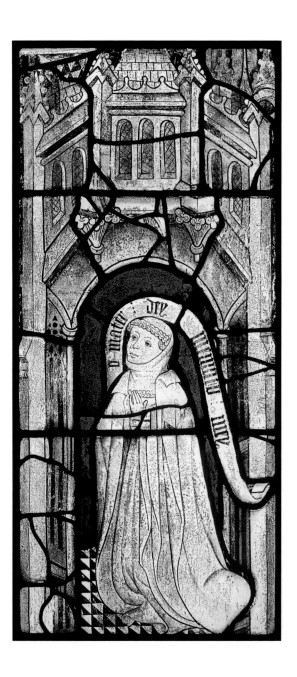

This donor panel is very similar in technique and style to a panel from the church at Mellé (Ile-et-Vilaine) in Brittany depicting the rector of Mellé and *officialis* of Rocher with St Catherine, now in the Cleveland Museum of Art (1921.106 Dudley P. Allen Fund). The architectural vocabulary of the female donor panel closely resembles that of glass from Brittany: the centralized perspectival arrangement of the framing and the use of rather large balls on the crockets and 'M'-shaped canopies beneath can be found both in the Mellé panel and in the *Notre-Dame de la Cour* (Côtes-d'Armor). Other panels from a Jesse window have also been associated with the Mellé glass, which probably dates to c. 1450. This donor panel was at one stage associated with standing figures of the Virgin and Child and a bishop saint, all with similar architectural canopies which did not necessarily belong to them originally. The Cleveland donor from Mellé also has an architectural canopy that is not from the same panel as the donor, and the two parts of the Cleveland glass have been dated thirty years apart. It seems that this female donor could have come from another part of the same church, perhaps dating slightly earlier than the Cleveland panel – but its canopy is certainly in the same style as the figure below (although not from the same panel). A similar luminosity and contrast of *verre blanc* and pot-metal glass may be found in England in the first part of the fifteenth century, but grisaille glass was also particularly popular in Brittany in the early fifteenth century, notably in the choir of Quimper Cathedral. This panel is a charming and evocative example of a regional style that owes much to trends on both sides of the Channel.

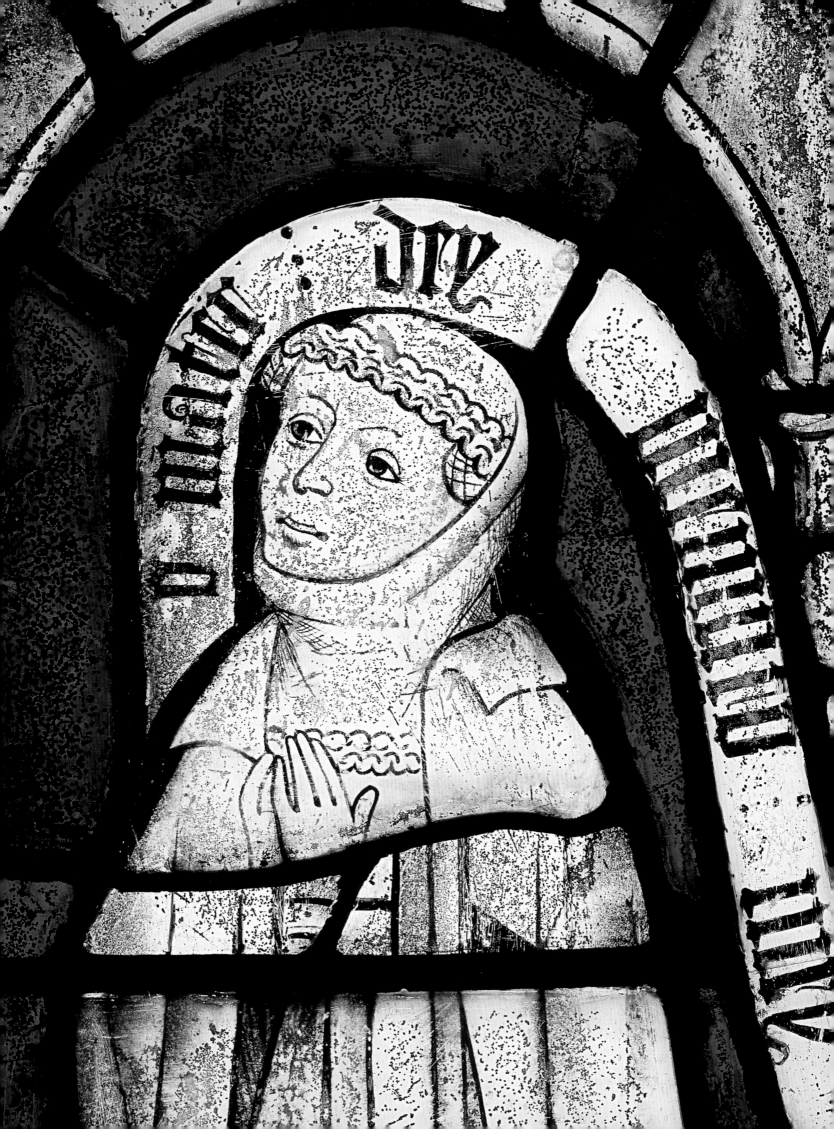

The Resurrected Christ Blessing

England, Norfolk?
c. 1450–70

16

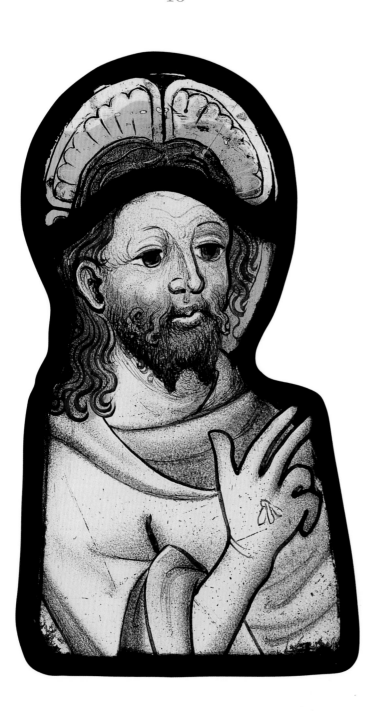

This arresting fragment can be related to a small but important group of glass from Norfolk. The distinctive large eyes and soft modelling recalls the St Mary Magdalene figure in the Burrell Collection and its sister panel in the Metropolitan Museum of Art (both of unknown provenance), which are related to glass still *in situ* at Cley in Norfolk. David King has argued convincingly that the fragmentary figures of St Petronilla and a female saint at Cley may be by the same artist, and that they can be dated to c. 1450–60 through analogy with the church building programme. It is likely that the fragment represents the resurrected Christ as he is shown in a shroud-like garment with bare arms, displaying the wound on his right hand.

Female Head

England?
c. 1400

17 The idiosyncratic and expressive
drawing of the eyes, with one eye
half closed and the other more fully
open, combined with the drawing
of the eyelids and lips, recall the
head of Sir James Berners (d. 1388)
at West Horsley (Surrey) and the
St George window at Wimbledon
(Surrey) of the late fourteenth
century. The pronounced jawline
and pursed lips, however, suggest
a slightly later date for this head.

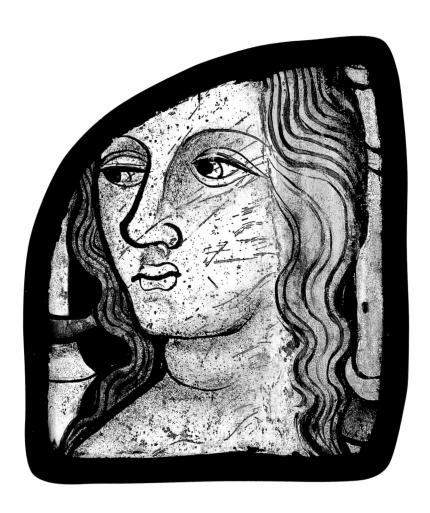

Ensemble with Lute-Playing Angel

England (larger pieces) and South
Netherlands (fragments)
c. 1450 and 1553

18 The angel is a fine example of
stained glass from East Anglia.
It may be compared with glass
at Salle (Norfolk) of c. 1450.
The carefully drawn hands, one
plucking with a plectrum and the
other formed into a bar-chord,
suggest the same attention to detail
as can be found at East Harling
(c. 1480). The quarries are dated
1553 and display the motto *confide
recte agens* [trust in doing right]
of the Anglo-Norman family of
de Glanville, who by the sixteenth
century had branches in the West
Country as well as in Suffolk. Such
quarries with monograms were
used in domestic glazing (e.g. the
domestic lights at 18 Highcross
Street, Leicester of c. 1500) as
well as in parish churches.

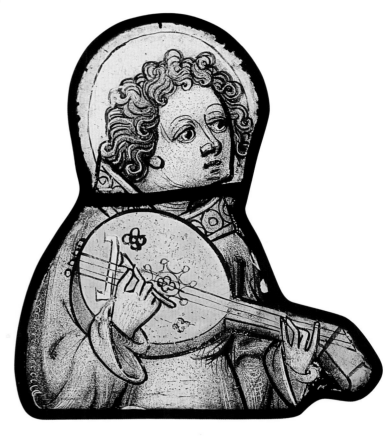

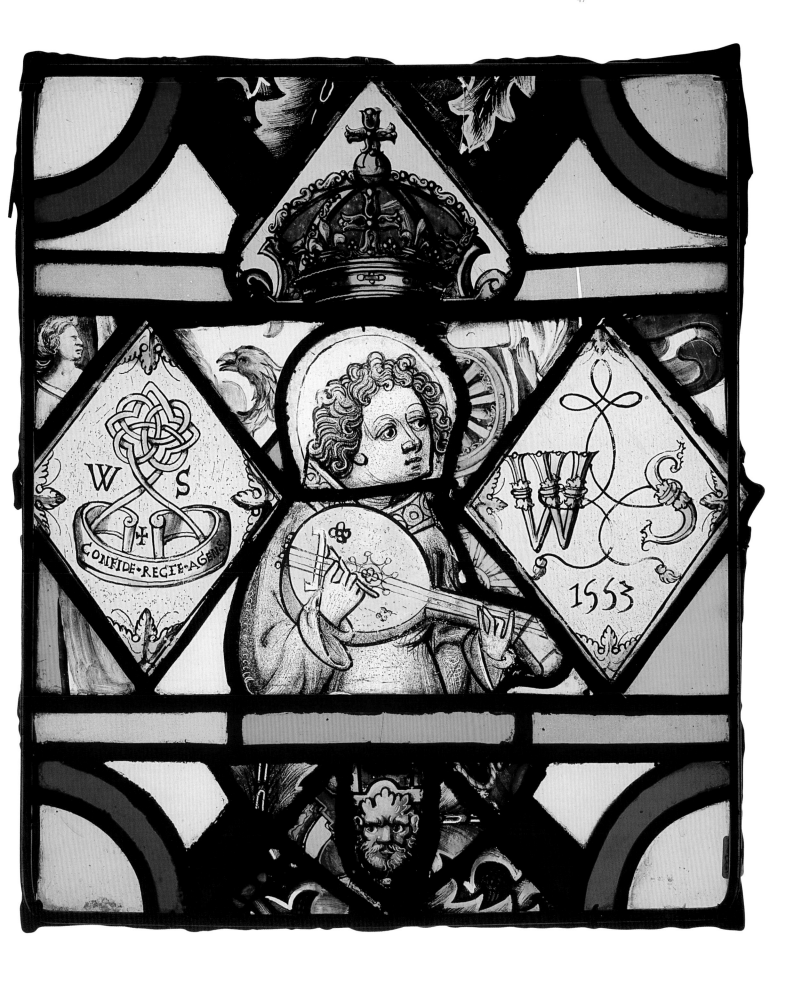

The Apostles Thomas and Philip

Germany, Cologne?
c. 1460–70

19 These charming figures of Apostles are probably from a series. Their attributes identify them as St Thomas (with the book and the spear) and St Philip (with the cross). A fragmentary St Andrew found in the crossing of St Cecilia in Cologne (Schnütgen Museum, Inv.Nr.M 29) displays a similar handling of the beard, in soft curls, and angular drapery style. The faces, with large contemplative eyes and soft modelling, recall Brigitte Corley's Dombild Master in Cologne, suggesting that they should be dated early in the last half of the fifteenth century.

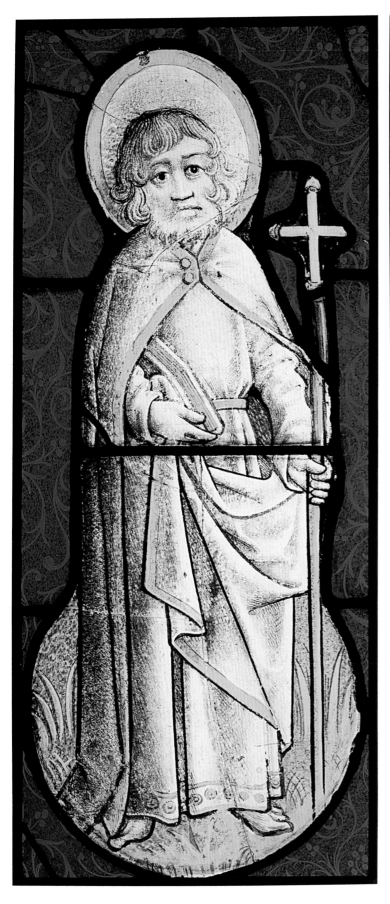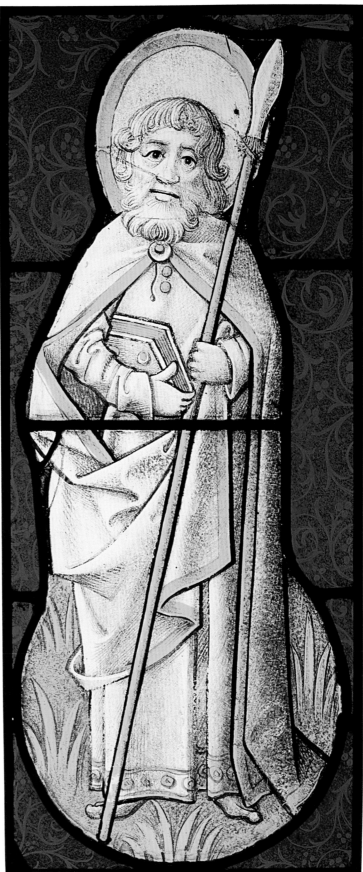

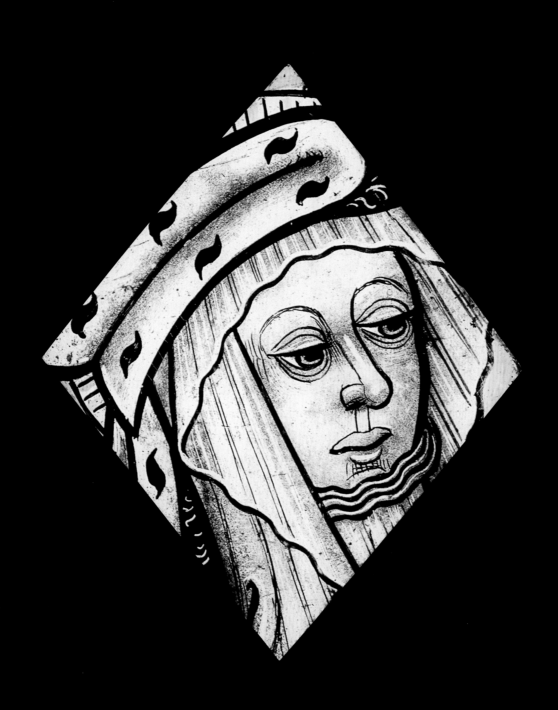

Head of a Woman (St Anne?)

England, Norwich?
c. 1480

20

This head bears all the hallmarks of a group of glaziers that worked at St Peter Mancroft (Norwich) before going on to work at East Harling (Norfolk). A comparison with the female heads from the *Life of the Virgin* at East Harling reveals many similarities. If the Virgin's head from the *Pietà* (see illustration) is compared with this fragment, numerous quirks of execution suggest the same hand was responsible. The double line above the eyelid, the darkened pupils with their outer ring, the straight noses, the lines of the upper lip and the cross-hatching below the lower lip are all almost identical. The elaborate headdress trimmed with ermine suggests that this may be the image of a saint rather than a donor – perhaps St Anne, who in the fifteenth century is often shown in a chinstrap veil similar to this (e.g. Thenford, Northants.). If this is so, the head could have formed part of the popular group of St Anne teaching the Virgin.

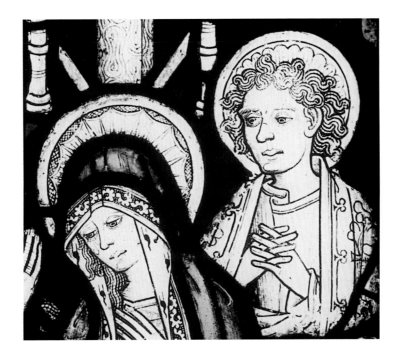

Detail of *Pietà*, c. 1463–80
(East Window, panel 45, East Harling
Church, Norfolk)

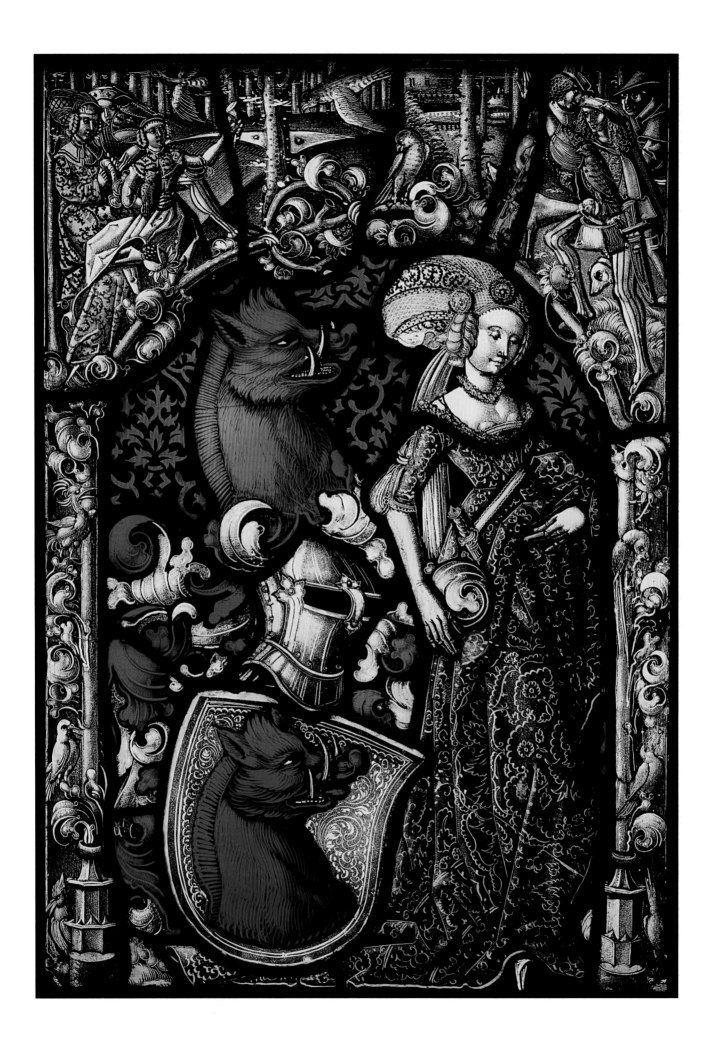

Heraldic Panel showing the
Eberler (gennant Grünenzweig)
Family Arms

Switzerland, Basel?
Circle of Housebook Master (Master
of the Amsterdam Cabinet)
c. 1480–90

21 This panel can be closely
associated with the work of the
Housebook Master (Master of the
Amsterdam Cabinet), one of the
most important engravers in dry-
point of the fifteenth century.
The early date and near perfect
condition of this panel also puts
it at the beginning of the
development of the typology
of secular heraldic stained glass
from southern Germany and
Switzerland. The Housebook
Master is named after the pen and
ink drawings in the so-called
Housebook of 1475–85 in the
collection of the Princes
Waldburg-Wolfegg (Swabia). He
is also sometimes called the Master
of the Amsterdam Cabinet because
of the stylistically related collection
of eighty prints formerly in the
collection of Pieter Cornelis,
Baron van Leyden (1717–88)
and now in the Rijksmuseum,
Amsterdam. He appears to have
been active in the Middle Rhine
region, working in the last quarter
of the fifteenth century both as a
painter and an engraver. Rüdger
Becksmann and Timothy
Husband have shown that his
models may be related to surviving
glass, notably the *Patricians'*
Tournament (private collection,
Germany) and the *Virgin and*
Child on a Crescent Moon in the
Metropolitan Museum of Art

(Cloisters Collection 1982.47.1).
The Housebook Master made
designs for stained glass with
supporters which are very close
in spirit to the Eberler arms design
(e.g. *Youth with Garlic in his*
Escutcheon and *Lady with*
Radishes), and the motif of the
growing arbour as a living arch
is almost a commonplace in his
work. Comparison between the
engraving of the *Virgin and Child*
on a Crescent Moon (Amsterdam,
Rijksprentenkabinet 20.43.8) and
the figure of the woman with the
Eberler arms shows that these are
not merely copied compositional
devices. The same inclination of
the face, half-closed eyes, small
sharp nose and round knob on the
end of the chin can be seen in both,
and the hands have long fingers
elegantly positioned, but with
bony knuckles. The lady herself
may also be compared with the
Idolatry of Solomon, where the
female figure raises her arm in a
similar gesture to lift up her dress,

Master of the Amsterdam Cabinet,
Virgin and Child on a Crescent Moon,
c. 1480, dry-point (Amsterdam,
Rijksmuseum, Rijksprentenkabinet)

21 continued

looks downwards at the same angle and again has the same small face. The hawking scene above could almost have come out of the Housebook itself. Comparison between the figures of young men in the *German Joust* scene (ff. 20v–21r) in the Housebook with those in the glass show that the same long legs with bony knees and elegant pointed shoes are used. The faces and the hair are treated in the same manner, and the flying hawk has the same profile as the birds in the *Castle of Desire* (ff. 23v–24r). Quadrilobe panels in Berlin (Staatliche Museen zu Berlin, Preußischer Kulturebesitz, Kunstgewerbe-museum, 07,164 and 07,163) draw on models by the Housebook Master, as do the stained glass panels of *St Martin Dividing his Cloak* by Master Erhard Reuwich for the Mainzer Amtskellerei in Amorbach (Odenwald) of c. 1486. These comparisons have even led to the identification of the Housebook Master with Erhard Reuwich. The closest comparison with the style of the Housebook Master in glass is with the *Patricians' Joust* (probably from the Haus der Patriziergesellschaft, Frankfurt). The treatment of the hair and faces in the *Patricians' Joust* and the Eberler Arms panel is close enough to suggest that they are by the same glass maker. The patron of this panel was probably a member of the Jewish banking family of Eberler from Basel – the red boar's head of his shield is an *armes parlante*s (or canting shield) symbolizing the meaning of the family name. This may have held anti-Semitic connotations, which they tried to escape by adopting the name of Grünenzweig when they converted to Christianity in the early fifteenth century. Matthis Eberler (c. 1440–1502) was one of the richest men in Basel, purchasing the Engelhof next to the Church of St Peter and furnishing it with the series of the *Nine Heroes* tapestries now in the Historische Museum in Basel. It seems highly probable that he commissioned this panel in Basel itself, but the decorative scheme may also be related to the stained glass workshop associated with Strasbourg which produced work for Ulm and Munich (e.g. the Scharfzandt Window, Munich, Frauenkirche, c. 1485) and with heraldic panels such as those from the workshop of Lukas Zeiner of Zurich, for example the panel of the Wiederkehr family (Zurich, Schweizerisches Landesmuseum) of 1500.

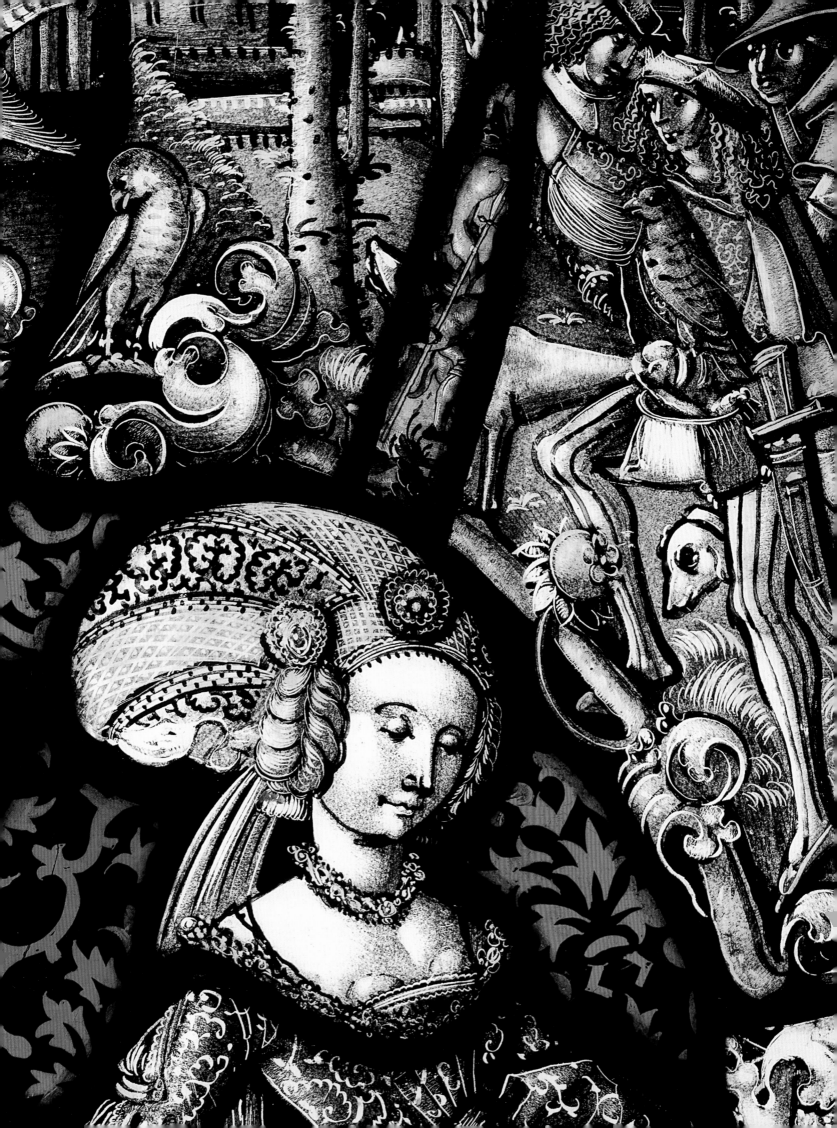

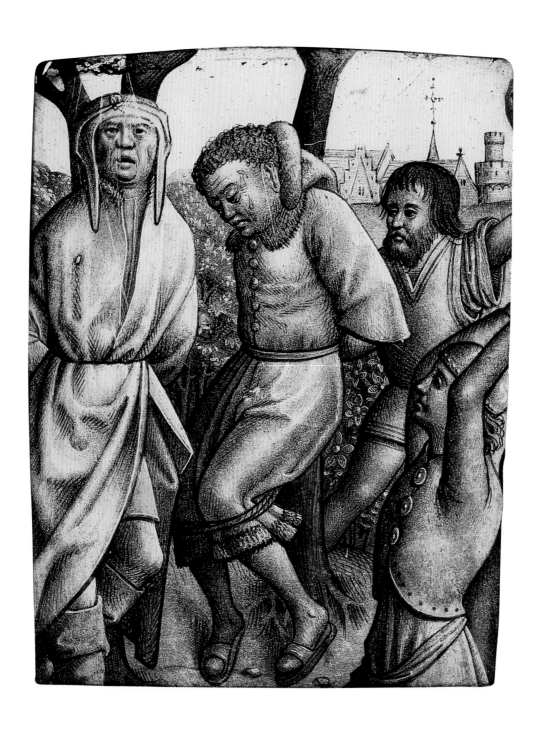

Fragment (from the Martyrdom of
the Ten Thousand?)

South Netherlands, Ghent?
Hugo van der Goes group
c. 1480–90

22 This tantalizing fragment can be
related stylistically to a series of
Flemish stained glass roundels
which have been christened 'The
Van der Goes group' because of
their similarities with drawings
that are either by or after Hugo van
der Goes (c. 1440–82), notably
The Meeting of Jacob and Rachel
(Oxford, Christ Church College
no. 1335). It is unclear exactly what

the relationship is between the
stained glass roundels and the
hand of van der Goes himself,
or exactly when the roundels were
made in relation to the artist's life
(he died in 1482 and much of the
stained glass appears to be c.
1480–1500). Comparison between
van der Goes's depiction of the
head of an Apostle at the foot of
the Virgin's bed in the *Death of the
Virgin* (Bruges, Musée Communal
des Beaux-Arts) and that of the
bound man in a fur coat on the
glass, reveals a similarly
characterized ear, furrows and
downward-turned expression.
The deliberate contrast of full-face
heads with three-quarter views
is also seen in the glass, and the
drapery has the characteristic
piping of van der Goes. When
compared with surviving roundels
attributed to this group for which
drawings survive (e.g. *Abraham
Blessing the Marriage of Isaac
and Rebecca*, Amsterdam,
Rijksmuseum NM 12243), the
small pinched faces and stippling
are very close in character and
suggest that the same artisans
were involved. It is unclear who
the two bound men are, but they

are dressed in the everyday
clothing of workers or artisans
and are set in a contemporary
landscape with gabled buildings,
towers and a weathervane. They
appear to be being flogged or
tortured by two mercenaries
dressed in semi-fictive clothing. It
is possible that this is a fragment of
a much larger scene, possibly the
Massacre of the Ten Thousand
Martyrs, which was the subject of
both a woodcut (c. 1496–97) and a
painting (1508) by Albrecht Dürer
(Vienna, Kunsthistorisches
Museum).

The Crowned Virgin and Child as
the 'Apocalyptic Woman Clothed
in the Sun'

Germany, Middle Rhine?
Late 15th century

23

The image of the *Woman Clothed in the Sun with the Moon at Her Feet* had developed from the fourteenth century onwards as a scene extracted from the Apocalypse of St John. The iconography is based on the description of 'a woman clothed with the sun, and the moon under her feet, and upon her head a crown of twelve stars' in the Revelation of St John the Evangelist (12:1). As the image gained in popularity it became associated with the doctrine of the Immaculate Conception, which the Franciscan Pope Sixtus IV tried to justify in a treatise of 1470 in the face of opposition by the Dominicans. Its popularity in the later Middle Ages was enhanced by an indulgenced prayer which gave remission of sins. It is one of the most popular forms of the Virgin and Child found in German and Netherlandish Glass of the fifteenth century. Close in iconography is the version in the Metropolitan Museum of Art (Cloisters Collection 1982.47.1.) which has been associated with a dry-point print of c. 1480 by the Master of the Amsterdam Cabinet (Rijksmuseum, Rijksprentenkabinet).

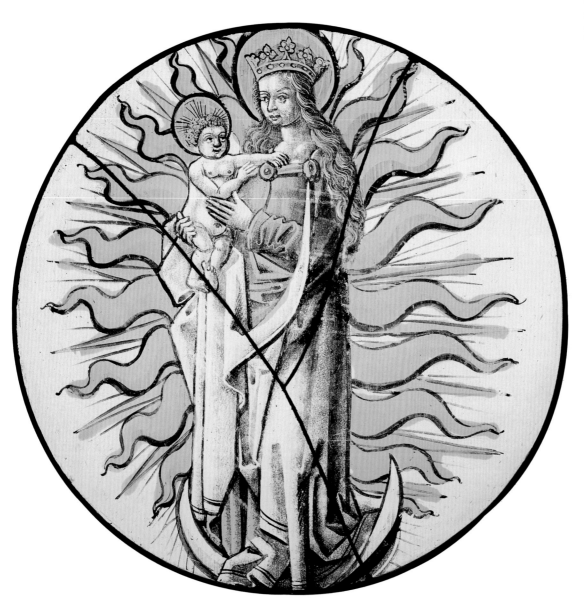

The composition for this roundel ultimately goes back to an engraving by Master IAM of Zwolle (B6-91.3), named after Zwolle to the east of Amsterdam. The rocky outcrop with the chalice perched on top, and the sleeping figures in the foreground, are combined in this print with a crowd entering by a roofed gate through a fenced garden. These are all features of this and other Netherlandish stained glass roundels of the same subject. Later prints by Dürer and a drawing associated with de Coecke ultimately depend on a combination of this idea and a print by Schongauer (B9) of the *Agony in the Garden*. There is a close resemblance between this piece and roundels in the Metropolitan Museum of Art (Cloisters Collection 1988, 304.2, c. 1515) and at Horsingham (Wiltshire, c. 1525), but the version here is closer to the print in the arrangement of the sleeping figure in the left foreground. This roundel also depends on the print stylistically for the densely crumpled drapery which forms a multitude of ridges. The Cloisters roundel appears to have moved away from the source of this composition – suggesting that an earlier date for this roundel, perhaps in the twenty years before 1500, would be correct.

Christ on the Mount of Olives

Netherlands
c. 1480–1500

24

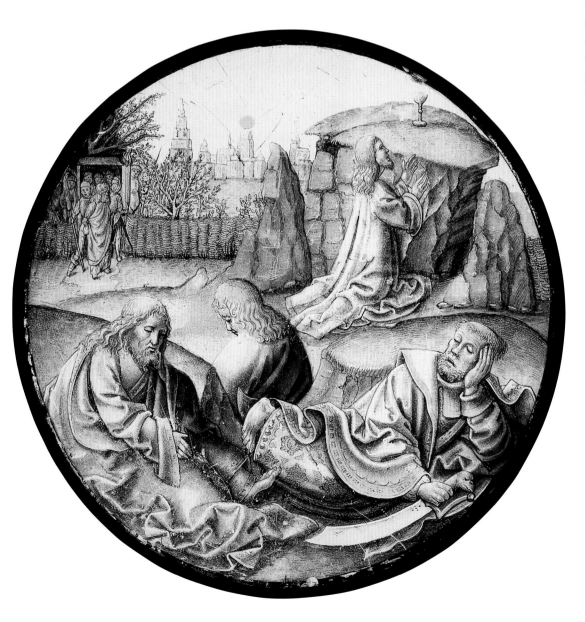

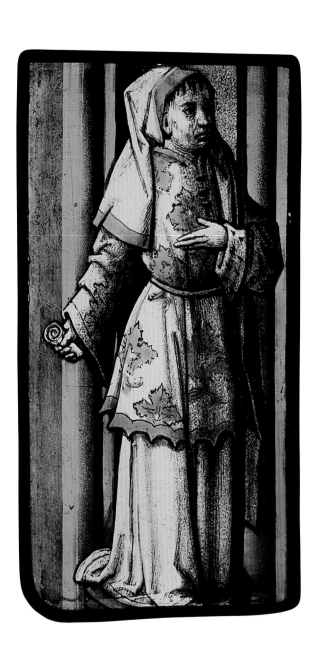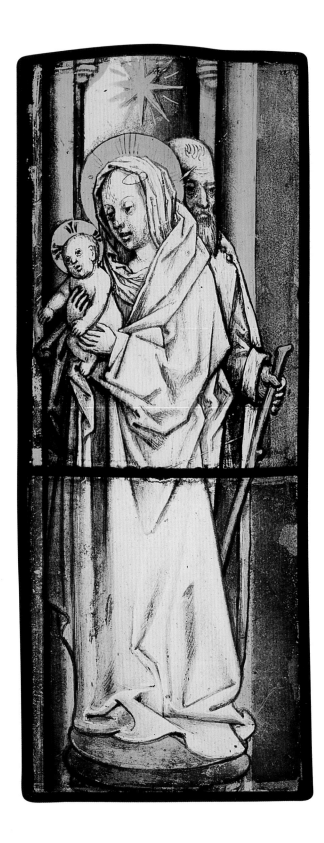

The Virgin and Child
with St Joseph, and St John the
Evangelist and a Prophet or Elder

South Netherlands, Bruges?
c. 1490

25

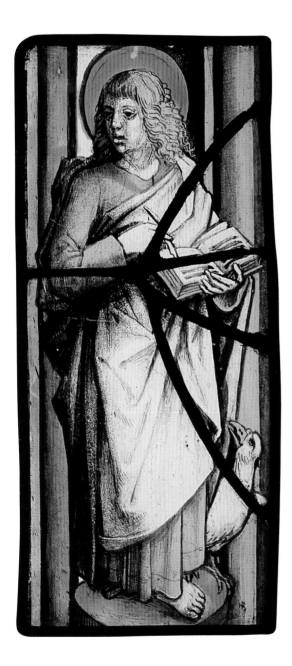

These fragments can be related stylistically to glass associated with Bruges (see no. 31 below) rather than Ghent, although there are correspondences with the so-called 'Van der Goes group' in the handling of the drapery. The clarity of the drawing and the simplicity of the setting, which convey an almost statuesque monumentality despite the small size of the fragments, suggest a date in the 1490s. Iconographically the pieces appear to follow the scheme of the triptych with *The Rest on the Flight into Egypt* by Hans Memling (Paris, Musée du Louvre RF 1974 30 and 1453-4, and Cincinnati, Art Museum 1956.11 and 1955.793). The Virgin stands looking out to the viewer's left in both the stained glass and the triptych, while St Joseph acts out his supporting role in the near background. The exact relationship of the prophet or elder on the right (wearing fictive clothing) to the scene is unclear, but both he and St John appear to come from the same ensemble. The sweetness of the Virgin's expression suggests the work of Memling; it may be compared with a stained glass roundel of *The Adoration of the Magi* based on a drawing from his workshop in New York (Metropolitan Museum of Art, Cloisters Collection, 1983.235). The crispness of the folds is also comparable to the painting of Gerard David in his early Bruges work such as *The Nativity* in New York (Metropolitan Museum of Art, Friedsam Collection, 1931 32.100.40a).

The Crucifixion

South Netherlands
1490–1500

26 This crucifixion represents the final flowering of the so-called 'Van der Goes group' of stained glass roundels. In drapery style and facial expression it may be compared with a drawing of *Joseph being Sold to the Ishmaelites*

in Berlin (Staatliche Museen zu Berlin, Preußischer Kulturbesitz, Kupferstichkabinett, Kd, 1982), which was the model for a stained glass roundel now in Pittsburgh (University Art Gallery 1140-65). The piped folds and contorted expressions in the Crucifixion panel are closer to the drawing than to the stained glass panel on which it is based. Even the trees and overlapping hills are closer to the drawing than the stained glass. This suggests an independent response to a model drawing of the crucifixion from the same source. The colourful and dynamically executed flower border appears to be integral to the piece and is a particularly early example of a type of composition which became more commonplace in the later sixteenth century. Similar borders can be found in a number of Flemish roundels (e.g. *Christ in the House of Martha*, Glasgow, Burrell Collection Inv. no. 361, reg. no. 45.470) of the early sixteenth century.

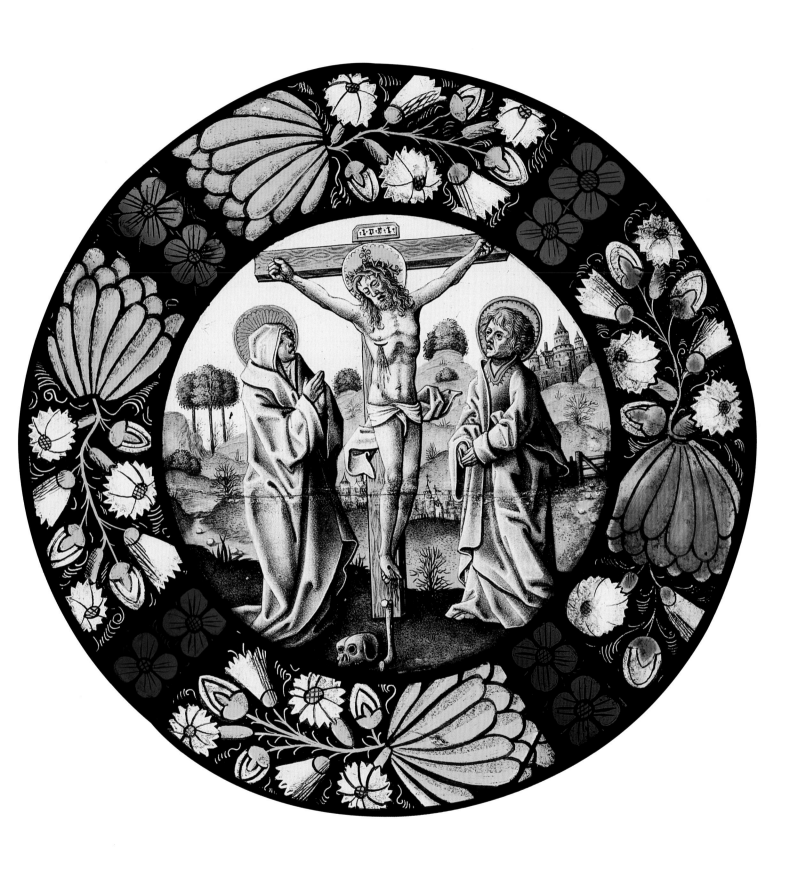

The Virgin Annunciate
Italy, Florence

*Domenico Bigordi, called
Ghirlandaio, and his workshop
c. 1491*

27 This Virgin Annunciate is perhaps the most important single panel of glass to have recently emerged as it can be confidently associated with Domenico Ghirlandaio and his workshop. The relatively small scale of the panel, and the evidence of only minor pitting, suggest that it may have been made for a semi-interior chapel space as a pair with an oculus containing the angel Gabriel. The attribution to Ghirlandaio is based on comparisons with his work for the Tornabuoni Chapel in Santa Maria Novella in Florence and with surviving drawings made for the commission c. 1489–91. As Cadogan has observed, Ghirlandaio and his workshop were no strangers to the design of stained glass. Giovanni Tornabuoni himself, in his will, extended his commission at Sta Maria Novella to include glass. Documentary evidence suggests that the glazier was Alessandro di Giovanni Agolanti, who also worked for the Tornabuoni at Prato and was a member of Domenico's studio. Although no further documents survive, the glass at Sta Maria Novella has been attributed on stylistic and compositional grounds to Domenico and Davide Ghirlandaio, perhaps with the aid of assistants. The glass attributed to Ghirlandaio at Sta Maria delle Carceri in Prato was less fortuitous; it was so extensively restored by de Matteis in 1900 as to render it unrecognizable as his work, but it is notable that an Annunciation was contained in this glass and that oculi were also glazed. The intimacy of the tondo makes the intervention of Ghirlandaio himself in the design more likely. Comparison between the Virgin Annunciate in the Capella Maggiore at Sta Maria Novella by Domenico and the Virgin in the stained glass tondo reveals that they are wearing the same distinctive gown with a convex neckline and a cloak fastened by an oval amber brooch. The blue cloak pulls away at a similar angle and the Virgin raises her hand to reveal that the sleeve of her gown is cut away, showing the linen chemise below. The same cloak and brooch can be found in a drawing done as a preparatory study for the *Visitation* in the Uffizi

Domenico Ghirlandaio, detail of
The Annunciation, c. 1490–91
(Sta Maria Novella, Florence)

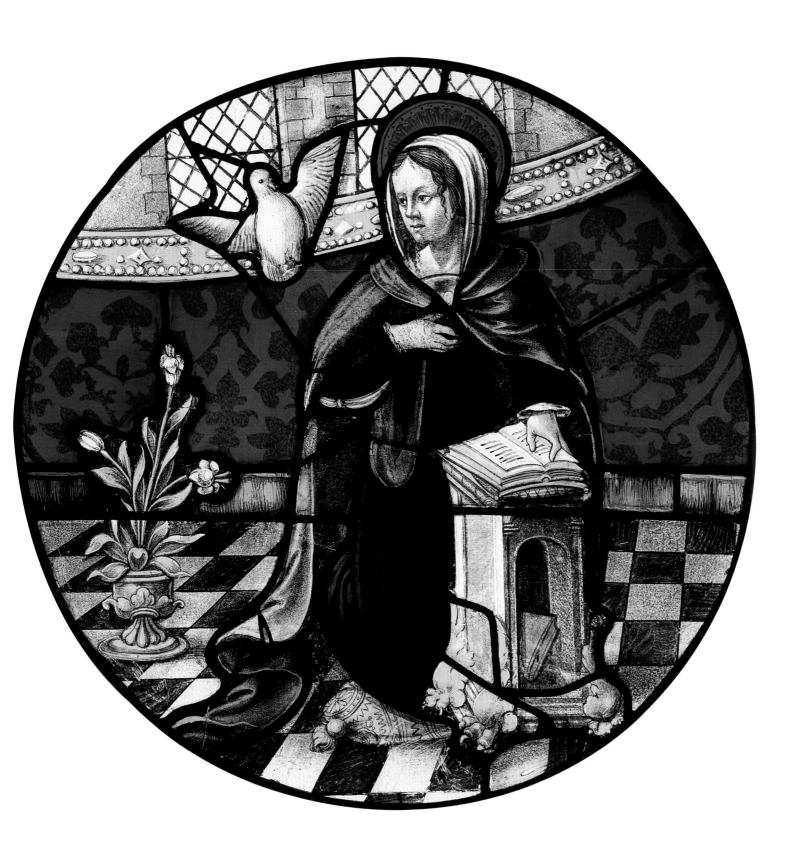

de'Benci' in the *Birth of the Virgin* at Sta Maria Novella. At the centre of the group of women led by Ludovica Tornabuoni, wife of Alessandro Nasi, a slightly older woman looks out at the spectator. She has the same bone structure, chin and small nose as the stained glass Virgin. The distinctive linear modelling which imparts depth and serenity to the face is here in such evidence that it seems impossible that Alessandro di Giovanni Agolanti – who, as Cadogan noted, was called *Sandro bidello dello studio* – could have executed it. It has all the hallmarks of Domenico Ghirlandaio's own hand. The prie-dieu with lion feet and the gilded vase full of lilies are in keeping with the vocabulary of forms expected in the studio of Ghirlandaio in the early 1490s. The cloth of honour, however, suggests that the glass maker, whoever he was, may have been aware of French glass of the last decades of the fifteenth century (e.g. Eglise de Saint-Rémi, Ceffonds [Haute-Marne], bay 12). Northern European glaziers are known to have come to Italy from the earliest times, the most famous of them being Guglielmo da Marcillat who worked in Rome, Cortona and Arezzo. It is tempting to suggest that just such a collaboration could have resulted in this remarkable tondo.

27 continued

(Gabinetto dei Disegni inv. 315 E). The face of the stained glass Virgin is rendered in the distinctive drawing style that only Ghirlandaio could achieve. It is best seen in the chalk drawing study for the so-called 'Ginevra

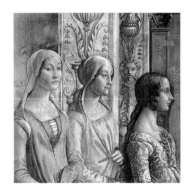

Domenico Ghirlandaio, detail of
The Birth of the Virgin, c. 1490–91
(Sta Maria Novella, Florence)

Domenico Ghirlandaio, study for
The Birth of the Virgin, c. 1490–91
(Chatsworth House, Derbyshire)

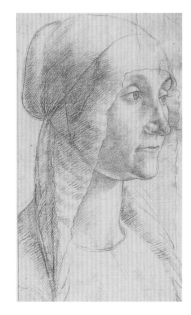

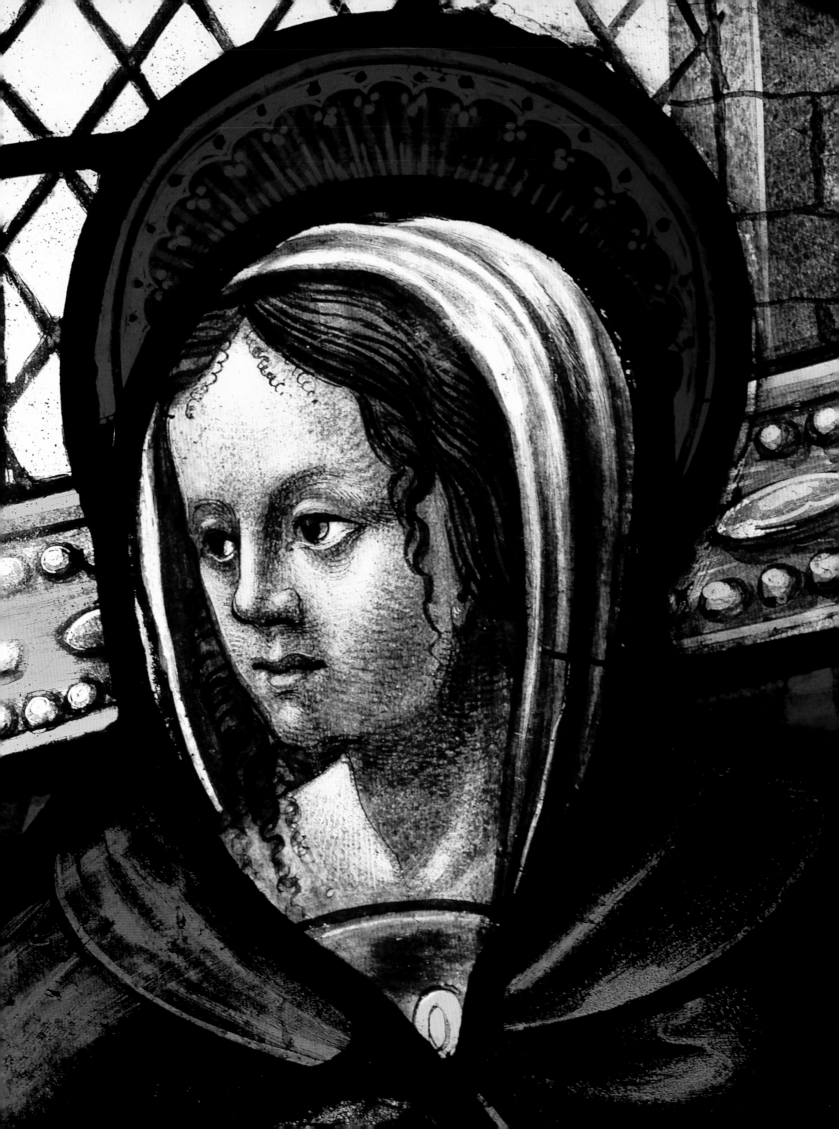

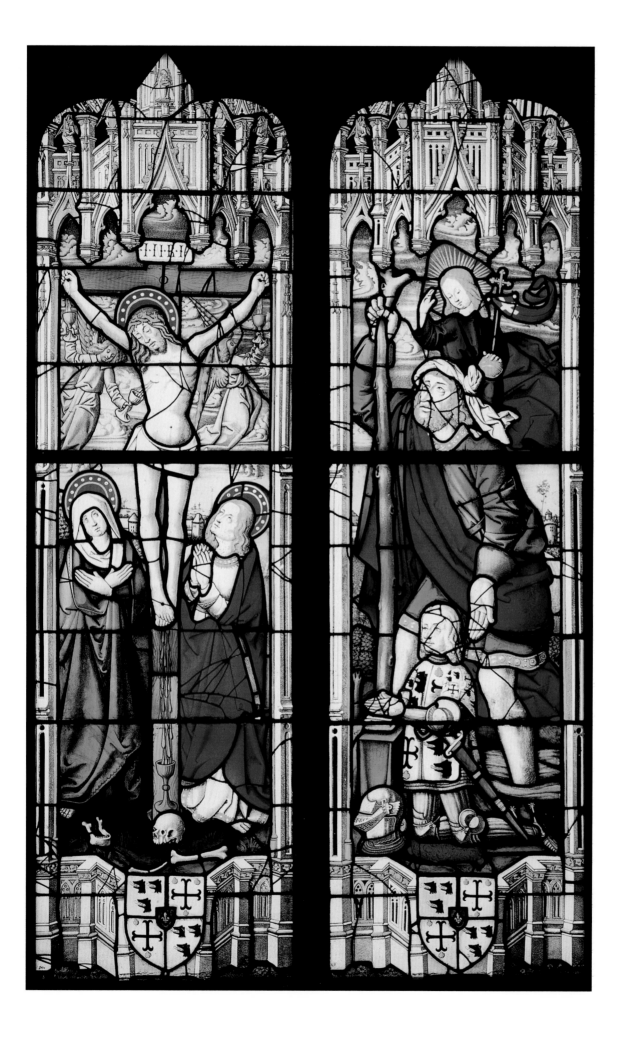

The Crucifixion with
St Christopher and a Donor

France, Lorraine/Burgundy
Jacot de Toul?
c. 1500–1510

28

These monumental panels are the two surviving lights from a three-light window of the greatest importance. The ensemble would have depicted the Crucifixion in the centre and the young armour-clad donor with St Christopher on the right, with further lost donors (perhaps the parents) on the left

(God's right hand). The near-perfect preservation of the panels and the quality of the painting is matched by the virtuoso command of the techniques of stained glass. These include the abrasion and re-firing of flashed ruby glass with the addition of silver stain (radiate halo of the infant Christ); silver staining of pot-metal blue with a wash of yellow to create a rich green (lining of the Virgin's cloak); and white enamel (Christ's flag). The grisaille blue of the landscape and the angels is also touched with silver-stained areas of yellow behind Christ and St Christopher, which adds to the effect of aerial perspective. Compositionally the window is close to that in the Eglise de l'Assomption, Arconcey (Côte-d'Or), where three lancets display an almost identical arrangement to that proposed for the glass here. Niches with small dado walls bearing the armorials of the flanking donors are crowned with pinnacled gables inhabited by music-making angels. The iconography of the angels catching the blood of the crucified Christ in chalices is almost interchangeable. Where the two differ is in the fact that the angels are not separately leaded here, but look forward to the enamel techniques of the sixteenth century by using painted blue grisaille with touches of silver stain. The style of the panels is very close to work which has been associated by Michel Hérold with

the *verrière* Jacot de Toul, both at Toul Cathedral and at the church of Saint-Nicolas de Port (both Meurthe-et-Moselle). Comparison between his work on the St Bartholomew panels (bays 100, 221 and 24a, c. 1510) reveals many similar traits of drawing: each hair of the eyebrows is singled out, the upper and lower eyelids have been clearly delineated, and the shading has been created with an extraordinary attention to detail. The whole composition has a statuesque monumentality, which is enhanced by the quality of execution. The canopy work and the confident use of colour at Saint-Nicolas de Port are in keeping with a date in the 1510s, but the Crucifixion and St Christopher panels may well have been made a little earlier.

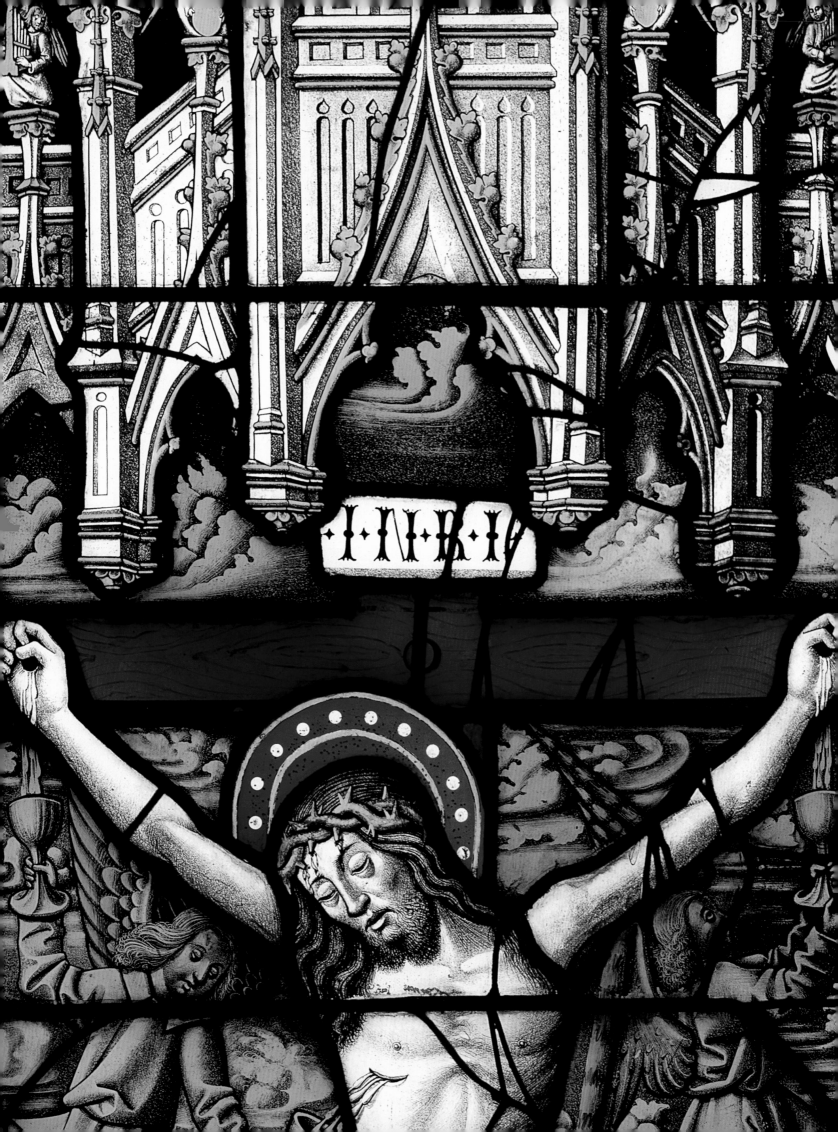

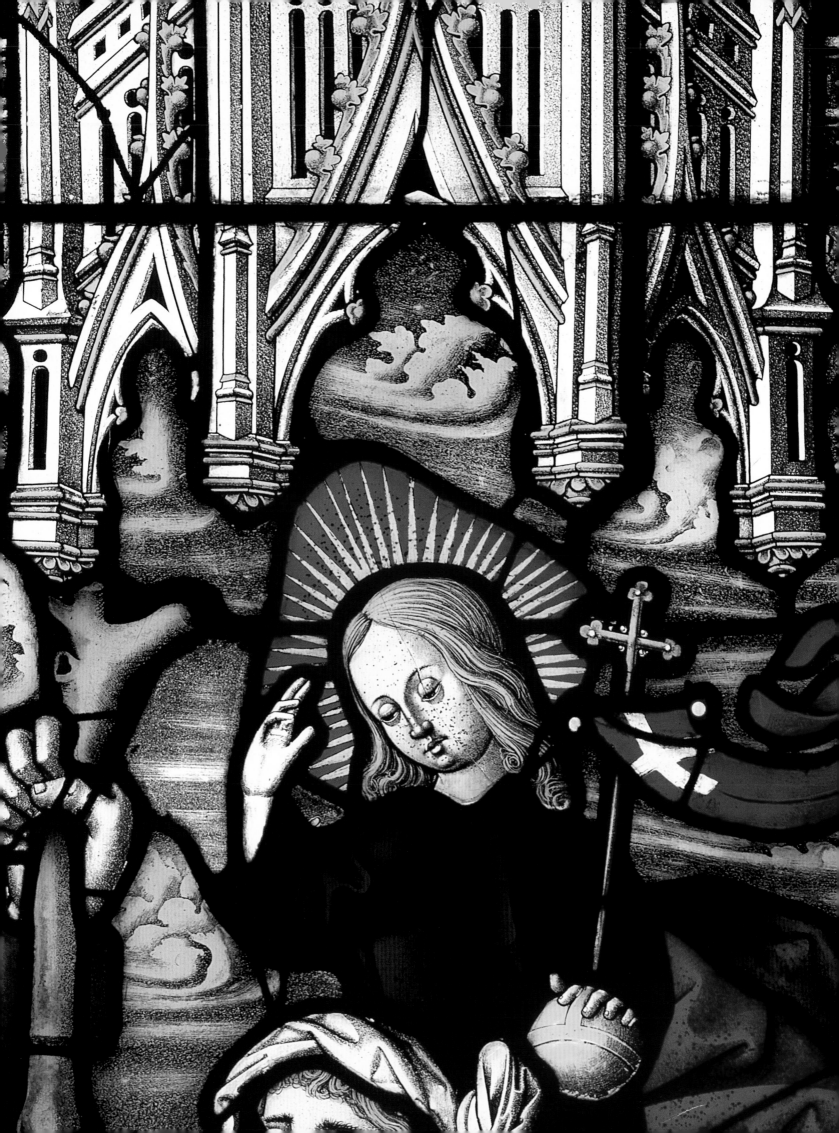

A Bishop Saint

France?
c. 1500

29 This fragment resembles the work of the St Giles Master, active in France in the last quarter of the fifteenth century, who is named after the panel of the *Mass of St Giles* in the National Gallery, London. The figure of a bishop (St Rémi?) from the reverse of this work may be compared with the glass fragment in respect of the modelling of the cheeks and the contemplative expression which they both share. The head shows a confidence in the use of silver stain and stipple shading that suggests a date around 1500. It may also be compared with the glass in the Chapelle de Saint-Julien, Saint-Marceau (Sarthe) of the early sixteenth century.

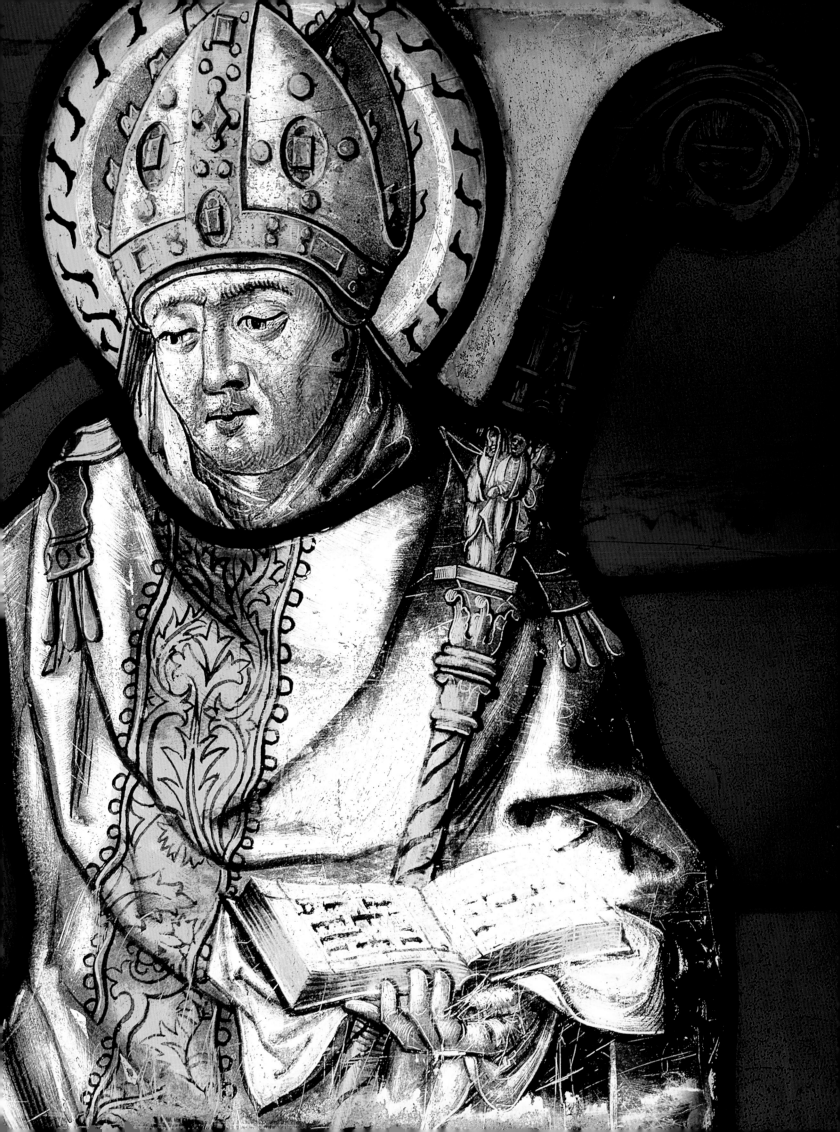

The importance of this roundel lies in the extraordinary touches of detail that have been included in the background. The scene depicts an idyll of monasticism that was under threat in the early years of the sixteenth century. The calm and holy activity of the monastic life is symbolized by the quietness of the scene. Smoke rises from the chimney of the kitchen on the left and a hutch perches against this side of the building while, on the right, a dovecote, another source of food, has a frame on its roof and we can see birds gathering in the sky. The doorway has a view through to a courtyard, but above it a roofed gable protects the image of the Crucifixion, while another monk sits on a specially constructed grassy bank around a tree with a small roofed shrine attached to it. Such tree shrines were evidently popular: an entire roundel has survived which features a man praying beneath one and seated on an almost identical grassy bank (private collection, Baltimore, Maryland). The Cistercian Abbot of Cîteaux, St Bernard, is probably depicted – he can be identified by his grisaille habit (rather than the black for St Benedict). Stylistically the roundel should be compared with the Sts Andrew and Cornelius in Bonn (Rheinisches Landesmuseum). The elaborate black cloth-of-gold backcloth and the soft but complex folds reveal the debt owed to the Cologne artist, the Master of St Bartholomew.

St Bernard

Germany, Cologne?
c. 1500

30

This beautiful roundel is a rare example in stained glass of one of the most popular scenes for private devotion in the Netherlands in the early sixteenth century. It depicts the moment when Joseph and the Virgin have stopped to rest after their flight from Herod's soldiers, sent to kill the Christ child. It was a particularly popular theme in Bruges, with Hans Memling, Gerard David and later Adriaen Isenbrant all producing versions. The iconographical source of this roundel may well be a combination of the two engravings by Albrecht Dürer which appear to have been inspired by the Master of the Amsterdam Cabinet's dry-point of *The Holy Family with a Rose Bush*

of c. 1490: the *Virgin and Child with a Dragonfly* (1494–95) and the *Virgin and Child with a Monkey* (1497–98). In the former, Joseph is seen half hidden by a grassy bank in exactly the same way as in the present roundel. In the latter, the river which separates a small farmstead from the bank on which the Holy Family rests may have supplied the idea of the distant town with towers and the river in the roundel. Despite these correspondences with Dürer's prints in terms of the composition, the tenderness and sensitivity of the drawing have much more in common with the work of Gerard David, particularly his version in Washington (National Gallery of Art), of c. 1510. Similar attention to the richness of clothing and a confidence in handling the drapery can be found in the *Adoration of the Magi* stained glass roundel in New York (Metropolitan Museum of Art, Cloisters Collection 1983.235), which depends on a drawing after Hans Memling.

Rest on the Flight into Egypt

South Netherlands, Bruges?

c. 1510

31

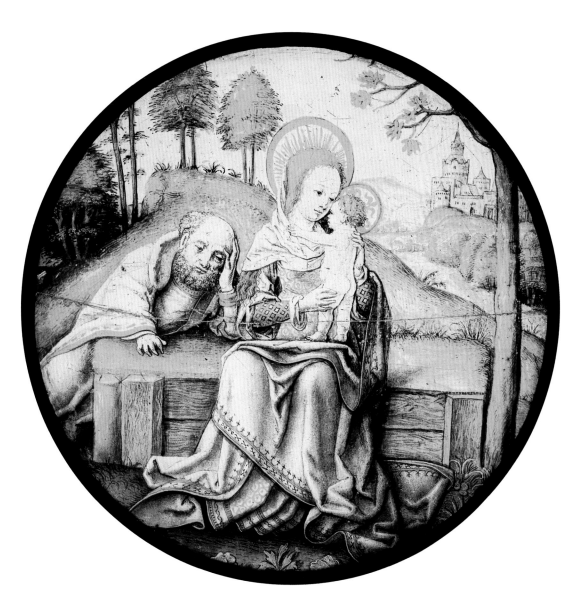

Set on a damasked and bordured field, this shield is of a shape that is typical of German jousting shields of the last decade of the fifteenth century. The use of flashed blue pot-metal glass with silver-stain yellow also suggests that a date in the last quarter of the fifteenth century would be appropriate.

The fleshy leaves and deep colours may be compared with a pair of heraldic shields of c. 1470–80 formerly in the collection of William Randolf Hearst and now in the Los Angeles County Museum, and with the heraldic roundels which Erhard Reuwich brought to the Herrenkamer of the Amtskellerei at Mainz in 1486.

Heraldic Roundel with the arms of
Ebra (gennant Pfaff)?

Germany, Augsburg?
c. 1480–90

32

This heraldic achievement is presented on a finely damasked and bordured field with a fine example of the barred and crowned helm in the crest. The barred (or buckled) helm was subject to regulations imposed after 1487 in German lands to prevent non-noble families from using them, but like the crown or coronet (which was originally reserved for kings and archdukes) it became more and more widely used by armigerous families in the fifteenth and sixteenth centuries. The arms pertain to the family of Rummel von Lichtenau near Nuremberg, and from the shape of the shield and the helms should be placed in the first quarter of the sixteenth century.

Heraldic Roundel with the Arms
of Rummel von Lichtenau

Southern Germany, Nuremberg?
c. 1510–30

33

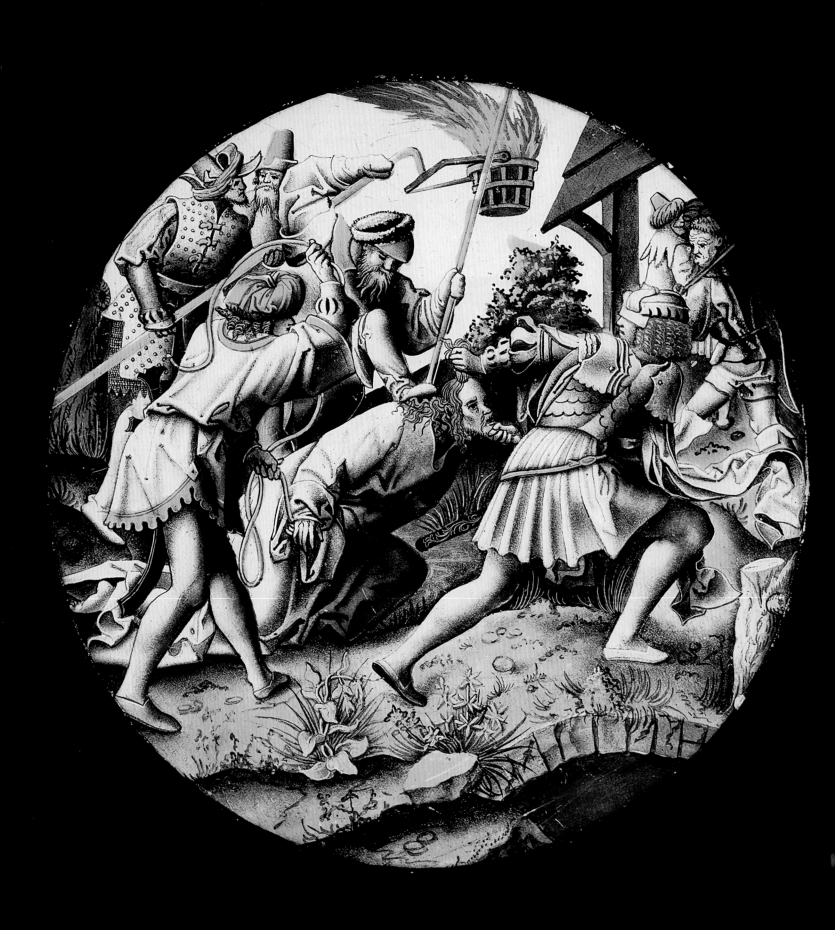

The Arrest of Christ

North Netherlands
After the Master of the Death of
Absolom
c. 1500–1510

34　This fine roundel is unique in its portrayal of Christ alone with his captors after the kiss of Judas. It is this moment that Hieronymus Bosch chose for his grisaille shutters for the *Temptation of St Anthony* triptych (Lisbon, Museu Nacional de Arte Antigua) of c. 1500. In the Bosch triptych, St Peter, in the foreground, is isolated from the main scene by means of a small stream crossed by a plank of wood. Judas skulks away on the left; and Christ, in the distance at the roofed gate to the garden, is seen being dragged on his knees by a crowd of soldiers. No other single scene with this composition and without the presence of St Peter appears to have survived. The roundel shares a number of features with the work by Bosch, namely the gate, the stream and the way in which Christ is being pulled along on his knees. It appears to be a further development of the theme, which adds dramatic focus to the scene. The *Arrest* has many of the idiosyncrasies of drawing found in the stained glass roundel of *The Betrayal* (London, Victoria and Albert Museum 393-1874) which has been associated with the circle of the Master of the Death of Absolom – so called after a drawing in Paris (Musée du Louvre, Département des arts graphiques 19.218). Although the drawings from this group often do not correspond closely in style with the stained glass roundels with which they have been associated (notably the *Ecce Homo*, in the Rijksmuseum), the correspondences between the roundels themselves are often closer. In this case the face of Christ, which has shadows to strengthen the cheekbones, and the emphasis on movement and light, are very close to the *Betrayal*. The attention to detail on clothing and in the pebbles and grasses underfoot is also strikingly similar. The torch, which spreads its flames back as it moves forward, adds a particularly evocative twist to the scene.

St Fiacre and a Benedictine Abbot
Saint with a Donor

France, Lorraine
c. 1510–15

35 This imposing and near life-size pair of French Renaissance windows may come from the Eglise de l'Assomption de la Vierge at Gondreville (Meurthe-et-Moselle), where there was a famous shrine with stone images around a fountain or well of

Sts Sebastian, Fiacre and Anthony. Certainly the Irish hermit Fiacrius (St Fiacre) is represented here along with his attribute, the spade. He was drawn to France by the Burgundian saint, Faro, the miracle-working Bishop of Meaux, and was especially noted for his charity to the poor in founding a hospice. He is also known as the patron saint of gardening because of his self-sufficiency in growing food for himself around his hermitage, which women were strictly forbidden to enter. He was a popular saint in early sixteenth-century France, and a large window, showing him being received by St Faro and then digging, survives at Saint-Maclou, Troyes (Aube). The donor who kneels before the Abbot wears his hair just above the collar of his fur-lined gown, and his bear-paw shoes are held on by a strap over the instep; both these features suggest a date c. 1510–15 when

these fashions were popular. The scalloped niche settings and perspectival tiled floor with a cloth of honour draped across the architecture are also found in French glass of the period c. 1510 at the Eglise Saint-Julien, Saint-Julien (Jura), but the bravado of the painting, with shadows thrown across the floor and sketchy foreshortening of the faces, is almost unique to these panels at this date.

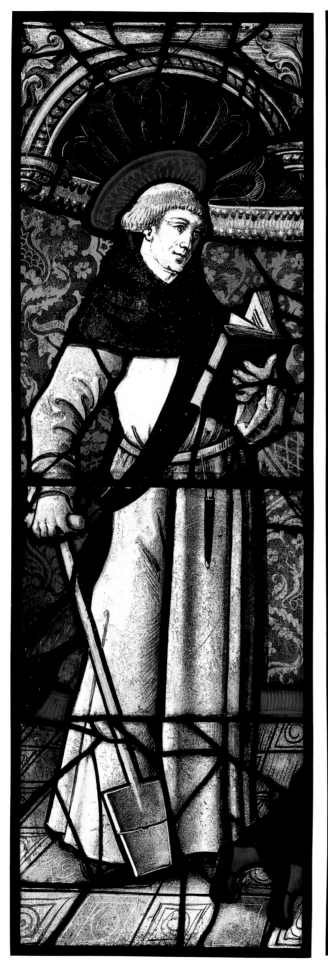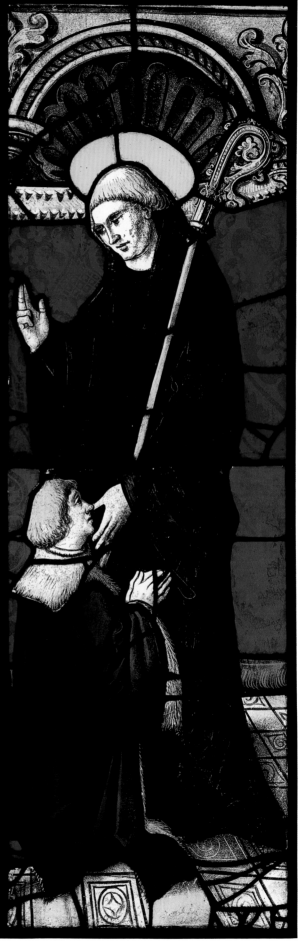

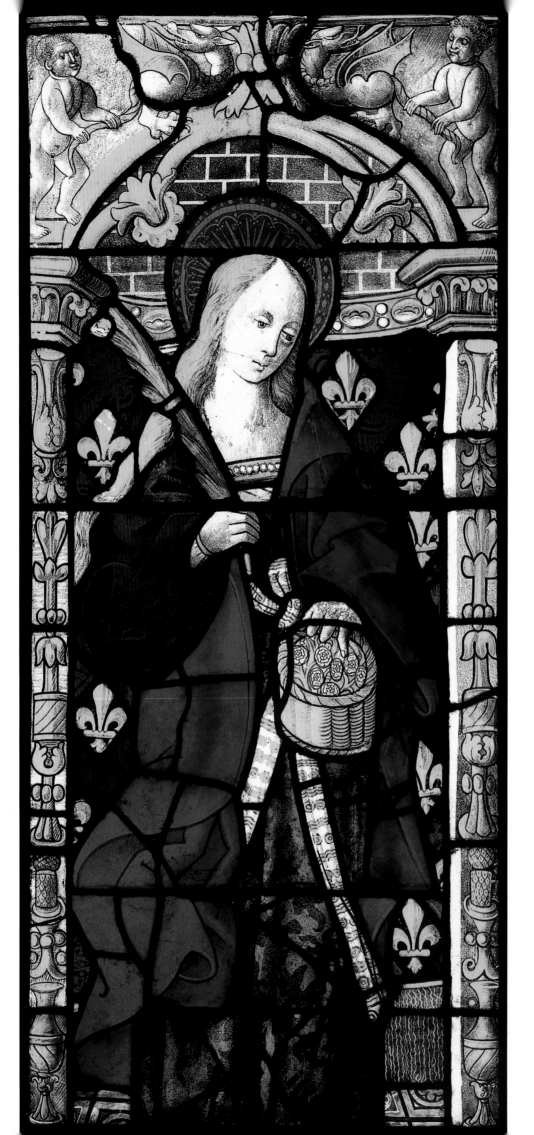

St Dorothy

France, Burgundy
after 1510–20

36 The window has many direct correspondences with the decorative scheme and style of drawing found in the stained glass installed in the Eglise de Saint-Saulge (Nièvre) in Burgundy after c. 1511 and was probably made by the same workshop. It depicts St Dorothy carrying her attribute of a basket of flowers and a martyr's palm. The flowers recall the story whereby she was mocked by a man called Theophilus when she dedicated herself to Christ 'in whose garden full of delights I have gathered roses, spices and apples'; he asked for some; and after her martyrdom an angel appeared to him carrying flowers and fruit. She was particularly revered by brides, midwives and newly-wed couples. The windows at Saint-Saulge were certainly installed after 1511, as a clear reference is made to Albrecht Dürer's woodcut of the Gnadenstuhl Trinity executed in that year in one of Canon Jean Boulu's windows (bay 3). The St John the Baptist from this window displays a border of acanthus and vases similar to the surviving border glass in the St Dorothy window, but it is the putti who play in the spandrels of the arches in the window donated by the Miard family (bay 4) that suggest a close workshop correspondence for the St Dorothy. Comparisons between the head of St John in the second of Jean Boulou's windows (bay 5) and that of St Dorothy suggest that the two could have been executed by the same artists. It is not possible to show conclusively here that she came from the church of Saint-Saulge, but it is known that there were repairs made to the glass in the seventeenth century and that all the glass was restored in 1901 by the workshop of E. Socard and H. du Basty and again by F. and P. Chigot in 1952.

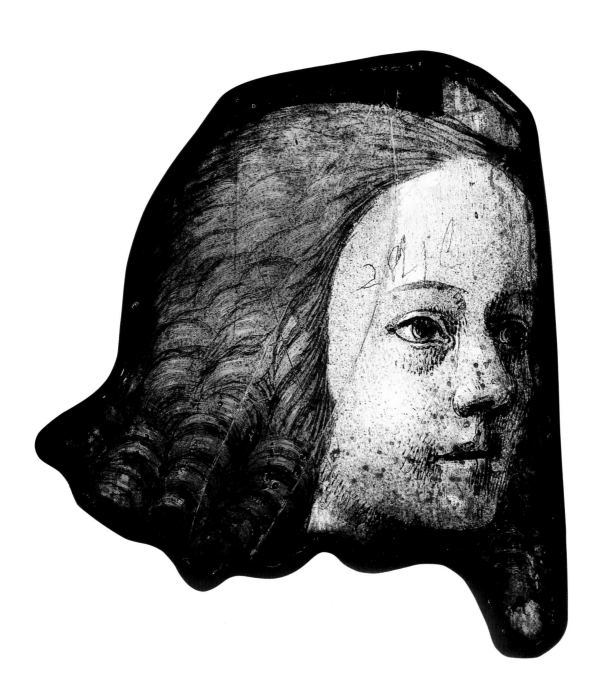

37 This beautifully modelled head belongs to the spear-bearing angel from the Instruments of the Passion group in the first light of the West Window of St Mary's Fairford. It was probably taken out at some stage after the great storm of 1703 when the Last Judgement was extensively damaged. It is somewhat ironical that the greatest damage to the glass at Fairford, the only parish church in England to retain glass from all of its twenty-eight early sixteenth-century windows, was through an act of nature. The glass was installed just before the deprecations of the reigns of Henry VIII and Edward VI, but survived the Reformation and the Commonwealth through a combination of necessity – replacement of so much glass would have cost a great deal more than just obliterating the more offensive images (either with washes of paint and abrasion or the destruction of faces) – and subterfuge: it is probable that the windows were removed rather than destroyed during the edicts against images that were enacted between 1641 and 1643. The good repair of the windows at Fairford owes much to generations of proud and far-sighted parishioners, in particular the Rev. F.R. Carbonell, the vicar appointed in 1888. He was instrumental in the re-leading of the windows and the re-setting of glass that was misplaced (owing to generations of repair, forced removal and re-installation). In 1889 the firm of Lavers, Barraud and Westlake were engaged in re-glazing the windows, but only after hundreds of pieces of glass had been retrieved from parishioners who had kept them in their homes, almost as heirlooms. Many pieces were never recovered and N.H.J. Westlake reported that he had seen glass from Fairford on sale in Belgium. This head, which is the only recorded piece not in the church, appears to have come from his collection before entering that of Keith Barley of the Barley Glass Studio, which is currently entrusted with the conservation of the glass.

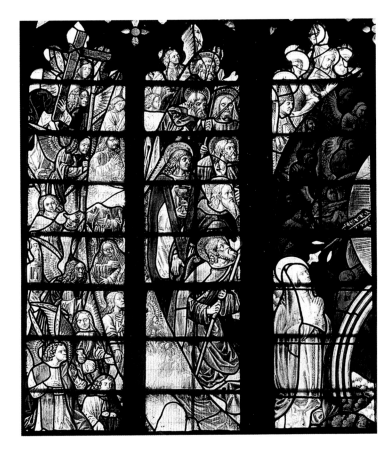

Armorial panel of the
Mollenberg(?) family of Bavaria

Switzerland, Zurich?

c. 1510–15

38 The setting, under a coffered arch with decorated pilaster strips leading to quadripartite capitals and billowing blue clouds, recalls glass which has been associated with Antoni Glaser and designed by Hans Holbein the Younger for the canton of Basel's contribution to the *Standscheiben* at Cloister Wettingen (Argau). These *Standscheiben* were public displays of glass in secular and religious settings that affirmed the association of local families, guilds or towns with a place or building. Many of the panels for Wettingen were made in nearby Zurich, and it is of no surprise that the simple drapery folds and dark palette also recall the stained glass made to designs by Hans Leu the Younger of Zurich for the same series (especially the panel of St James). Of further interest is the depiction of a man shooting a *hackbut* in the splay on the left. This is of a c. 1505–10 design and is a rare depiction of an early gun in stained glass.

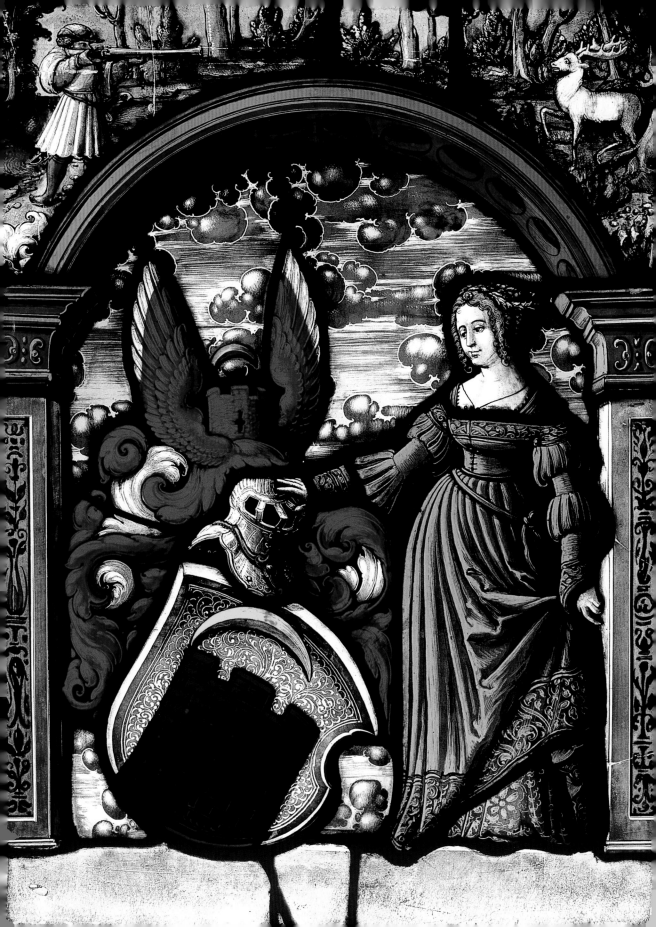

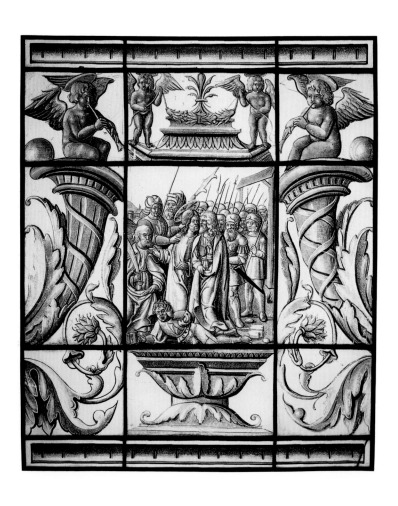 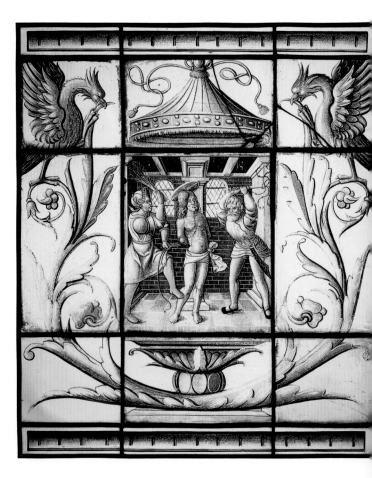

The Arrest of Christ, the Flagellation and the Way of the Cross

North Netherlands
c. 1510–20

39

The sturdiness of the figures combined with the simple characterization of the faces suggest that this series should be associated with a roundel of the *Arrest of Christ* of c. 1500 (London, Victoria and Albert Museum 393-1874). This roundel is related to the work of the so-called Absolom Master, named after a drawing in Paris (Musée du Louvre, Département des arts graphiques 19.218). Comparison between the heads, particularly the treatment of hair, beards and eyes, suggests that the artist of this series should be related to the stained glass roundel rather than the drawing. He evidently knew this artist's work well, but did not supply the complex settings and attention to detail found in *The Arrest of Christ*. That this series was executed a little later than the conservatism of the figure style indicates is confirmed by the bear-paw shoes worn by one of the soldiers flagellating Christ. Timothy Husband has noted a similar anomaly in a series of roundels of the *Occupations of the Months* (e.g. *March*, Amsterdam, Rijksmuseum RBK-1984-41), which he dates to the 1525–35 period. The importance of these panels lies in the fact that, although they have clearly been cut down to fit their settings (note the cut-off sword of St Peter in the first panel, the feet in the second panel, the foot and beard in the third) they appear to form a genuine sixteenth-century ensemble. The weathering of the glass and the style of the putti sitting on top of the cornucopia suggest that the ensemble was put together soon after the glass was made. As such, it represents a substantial early survival of what was to become an important method of display in the sixteenth century.

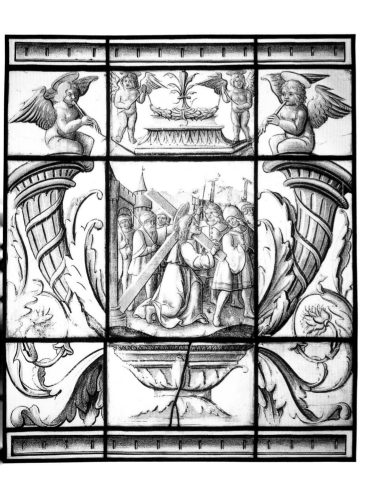

St George with the Arms of Speth
(or Spett)

Germany, Zurich?
dated 1517

40 This panel is executed with considerable technical aplomb and employs the most sophisticated techniques available to impart a jewel-like intensity to the colours. White enamel is used on voided flashed ruby glass to create an impression of fluidity and clarity, while silver-stain yellow and grisaille are used on the same piece of glass to denote gilding. Abraded ruby glass fades to add three-dimensionality to the defeated dragon. The panel is dated by inscription. St George bears the red cross standard and treads the dragon underfoot while he wears the very latest gilded armour. This panel may have formed part of a group of the armorials of the Speth family, which were formerly in the collection of Sybille Kummer-Rothenhausen in Zurich. Two others, which seem to come from Constance, are in a private collection at Hillsborough (California) and depict Diettrich Spett (dated 1530) and Jörg Spät von S. Georg (c. 1560?). The latter is of particular interest, as the arms are reversed in honour of a missing panel with which it would have formed a pair. It is tempting to suggest that the donor of the 1517 panel would have faced St George here, too. Standard bearers wearing contemporary armour were popular from the late fifteenth century until the middle of the sixteenth century. Examples from Zurich of the von Elgg family and the Schwyzer-Schmid families (Zurich, Landsmuseum) of c. 1513–15 are similar to the St George, which may also have been made in Zurich.

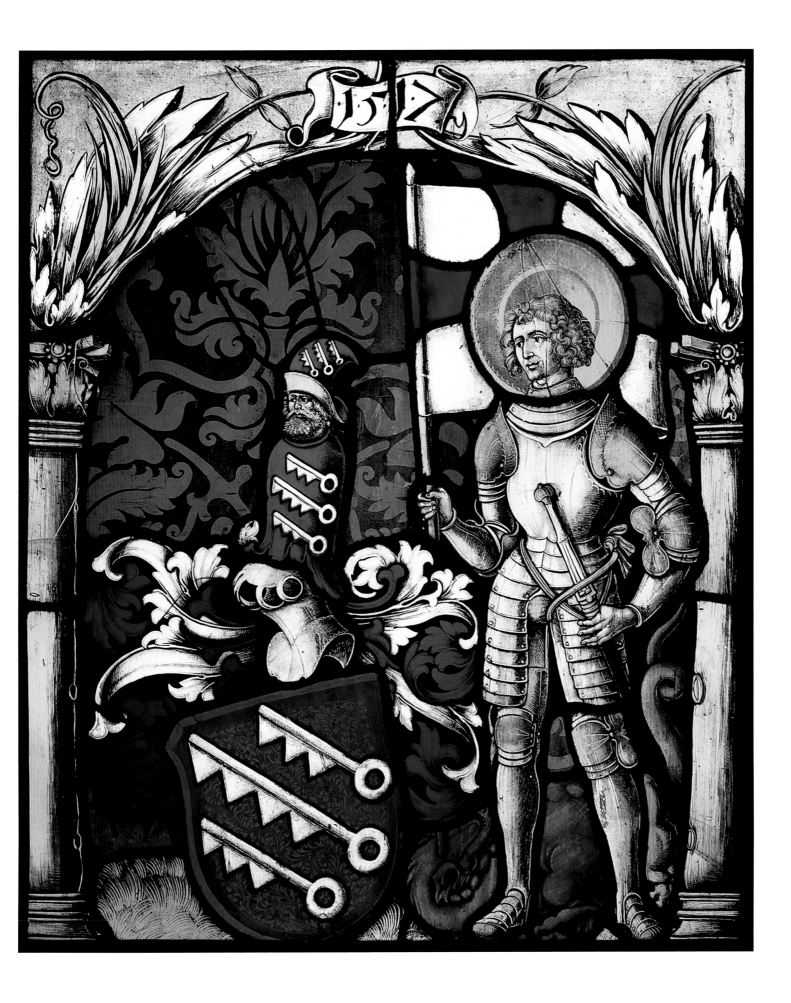

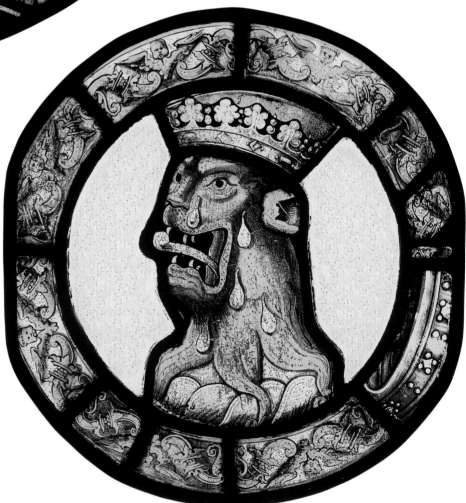

Heraldic Panels with the Arms and
Crest of the Duke of Suffolk

England, East Anglia?

c. 1520

41 These are the arms and crest of
Charles Brandon, first Duke of
Suffolk (d. 1545), son of Sir
William Brandon (probably of
Brandon in Suffolk) and Elizabeth,
daughter of Henry Bruyn of South
Ockendon, Essex. His father was

knighted by Henry VII and
according to Halle's chronicle
he was the standard bearer slain
by Richard III at the Battle of
Bosworth (1485). Charles was
brought up at court with Henry
VIII and was an esquire for the body
of Henry VII on his death in 1509.
He was one of King Henry VIII's
closest and most trusted friends
and was created Duke in 1514.
Charles's ambitions (particularly
marital ambitions) sometimes led
them to fall out; he was engaged
to (and forced to marry) Anne
Browne after she became pregnant,
and was refused by Elizabeth
baroness Lisle before marrying
Mary Tudor, Henry's sister, against
the King's wishes. When Mary
died he married Catherine
Willoughby, by whom he had two
sons – whose miniature portraits
were painted by Hans Holbein the
Younger (Royal Library, Windsor
Castle). On the Duke's death the
King insisted on a lavish burial in
St George's Chapel at Windsor
near the south door of the choir.

The armorial is an extremely rare
survival. The shield is emblazoned
in the *Armorial Jousting-cheque
for the Field of the Cloth of Gold* of
1520 (London, Society of
Antiquaries MS 136, part 2, folio.1),
this being the only immediately
contemporary survival. The
speedy rise of the Brandons adds
mystery to this armorial and it is
rarely discussed in the literature.
It shows the arms of Brandon
quartering the arms of Broune as
recorded in Peter le Neve's *Book of
Arms*; both are virtually unknown
before 1520, when this glass was
probably made.

A Premonstratensian
Canon of Berkheim

*Switzerland, Basel
Designed by Hans Holbein
the Younger*
c. 1520

42 This panel can be attributed with some certainty to Hans Holbein the Younger (c. 1460–1534) on the basis of comparisons with his own surviving designs for stained glass and his painting during his early period in Basel. It also contains motifs which can be associated with prints by Urs Graf (c. 1485–1527?), who was active in Basel at the same time. The significance of this find cannot be underestimated as it fills a gap in our knowledge of Holbein's artistic development at a crucial time in his career and suggests new lines of enquiry about his relationship with Basel artists and glass makers. The striking foreshortening of the inscribed *tabula* above the Canon, combined with the low viewpoint and monumental architectural swags, are all hallmarks of Holbein's stained glass designs of the period c. 1517–28. The vocabulary of forms used in the swags and leaves to the right of the figure show the same curling ridge and delicate shading as that found in Holbein's study for *The Crucifixion* (Basel, Öffentliche Kunstsammlung no. 1662.121). The plinth on which the Canon kneels is viewed from below at the same angle as that seen in the designs for a stained glass panel of Hans Fleckenstein (Braunschweig, Herzog Anton Ulrich-Museum no. z.38). However, it is the comparisons between the figure itself and Holbein's paintings, such as the double portrait of Jacob Meyer zum Hasen and his wife Dorothea Kannengießer of 1516 (see illustration), which are particularly convincing. In this portrait Jacob Meyer's hands – the distinctive thick fingers, the almost cursory bone structure, and the rendering of the fingernails in particular – are almost indistinguishable from those of the Canon. The head has

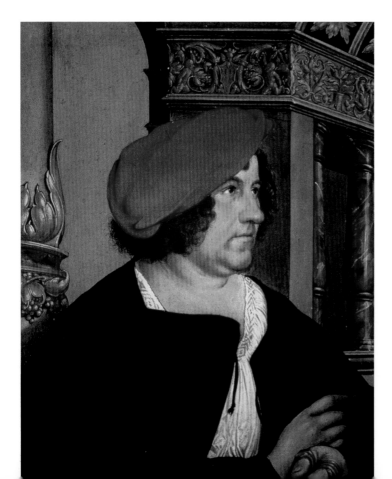

Hans Holbein, *Mayor Jakob Meyer zum Hasen*, 1516 (Basel, Öffentliche Kunstsammlung)

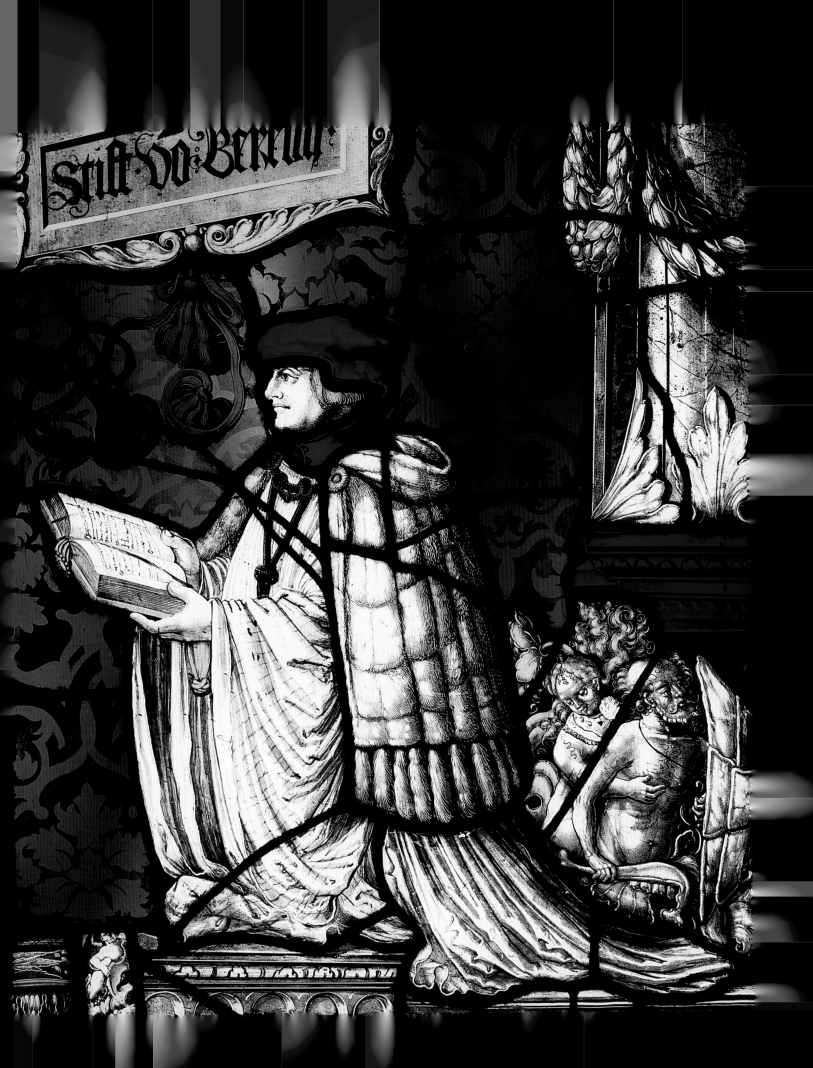

the stained glass panel. Of equal interest are comparisons with Holbein's later portraits, whether it is for the cloth of honour backdrops (e.g. *Portrait of William Warham, Bishop of Canterbury*, Paris, Musée du Louvre) or the interest in placing details such as sash cords or leaves (particularly in his distinctive rich green) close to the sitter's face (e.g. *Portrait of Thomas More*, New York, Frick Collection; and *Portrait of Henry Guildford*, Royal Collection, Windsor Castle). The Stift von Bercheim is a prebendary canon of the Premonstratensian order who was sponsored by the small church of Bercheim (or Berkheim). This was one of the *parochiae incorporatae* of the Abbey of Roth (Rott am Inn, south-east of Munich) and was rebuilt after 1759. The panel was almost certainly displayed in the monastery church rather than in the small parish church which supported the canon. His status is communicated through his

beautifully painted surplice with delicate ridged folds and his heavy fur cape. His learning is communicated by the open book he carries which is clearly written in a humanistic hand, rather than the elaborate gothic black letter script of his inscription. Behind the Canon can be seen a curious pair of figures whose iconography is linked closely to Mantegna's print of *The Battle of the Sea Gods* (H.V.15.5 and 6). This print was

42 continued

a similar emphasis on shading around the jowls, and the profile is constructed with the same balance of nose to mouth and chin, although it is more strictly in profile in the glass. The large berries and the gilded acanthus in the Meyer portrait are almost identical to the masonry leaves in

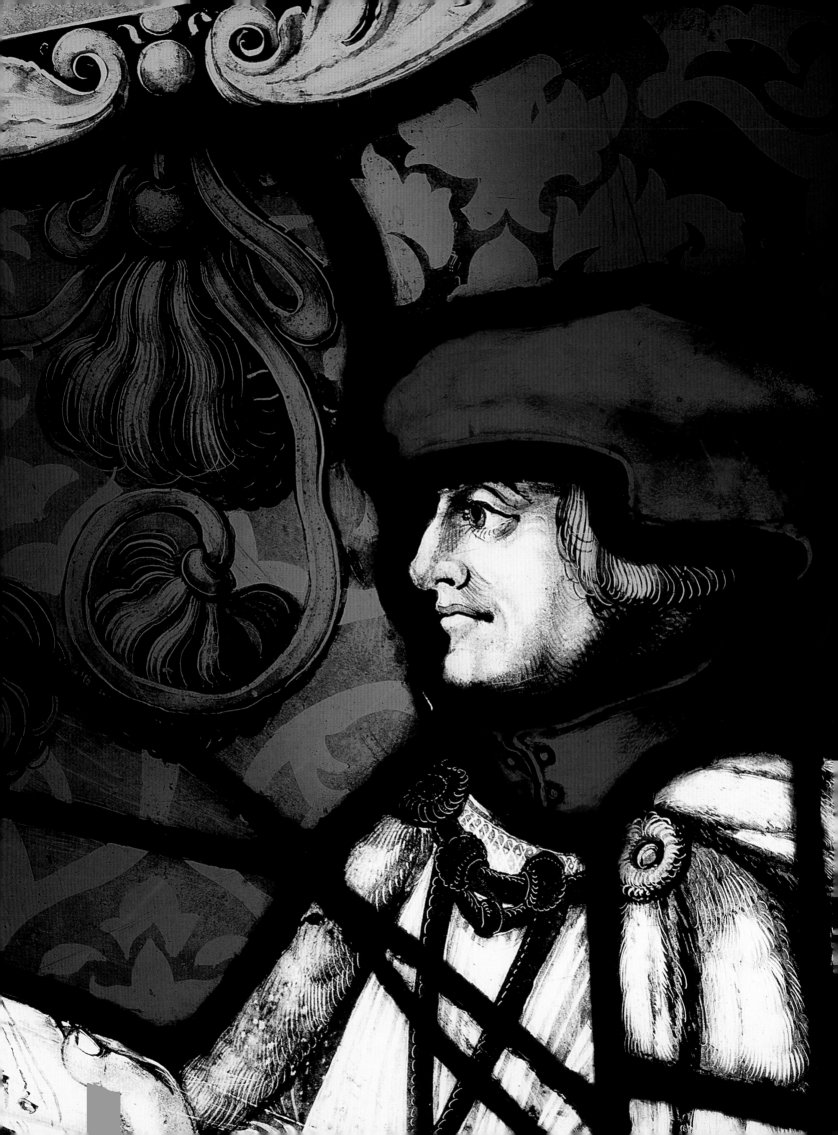

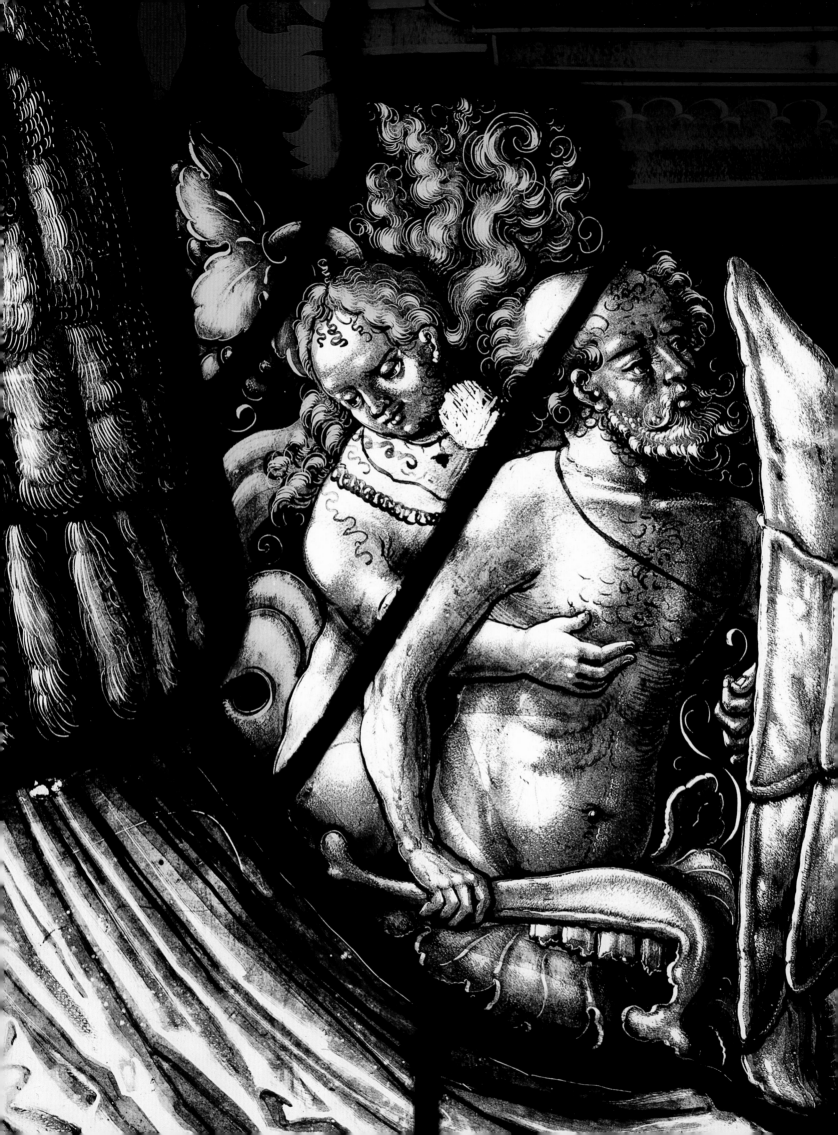

u.iv.57). The woman who clings to the sea monster, who carries a jawbone and shield, is very to close to drawings and prints by Urs Graf in terms of the hair details (particularly the corkscrew hairs over her shoulders), the necklaces of jagged lines and the splaying tresses (e.g. the drawing *A Woman Playing a Viol* of 1523 – see illustration). The monster's tortoiseshell shield and jawbone are borrowed from Dürer's prints, but the style of this group is entirely in keeping with that of Graf. He first trained as a goldsmith with his father and then as a stained glass painter with Hans Heinrich Wolleb of Basel (c. 1490–1527). Only a single piece of signed glass by Graf has survived (Zurich, Schweizerischers Landesmuseum, LM 1830); nevertheless, it shows the

same thick silver-stained hair picked out in careful ringlets as that seen in the woman's hair from the Bercheim panel. The melding of styles between the overall design, which suggests that the panel was designed by Holbein, and the iconographical and stylistic details, which reflect the work of Urs Graf, suggest that the two could well have collaborated on this glass.

42 continued

widely disseminated in northern Europe: it was used by Dürer in his print of *The Sea Monster* of 1498–99, and Urs Graf of Basel made a pen and ink copy directly from the original (Basel, Öffentliche Kunstsammlung,

Urs Graf, *A Woman Playing a Viol*, dated 1523, pen drawing (Darmstadt Museum)

St Sebastian

Germany?
c. 1520–30

43 The iconography of this panel is extremely unusual in depicting the seated St Sebastian: he is almost invariably shown standing or leaning against a tree or column. The sketchy drawing of the distance and the flowing robes of the two archers who walk away from the scene suggest a date in the 1530s. The figure of the saint appears to owe a debt to Italian sources, both in prints and in ceramics. Images of St Sebastian bound to a tree with only two archers present can be found in books of hours in northern Europe in the later fifteenth century, such as the Hours of Detmar Basse (Philadelphia, American Philosophical Society). Master ES also uses this format in his engraving of 1467 (Munich, Bayerische Staatsbibliothek). The treatment of the torso of the saint, however, can be related to engravings by Marcantonio Raimondi – such as *The Judgement of Paris* of 1514–18, where the chest and folded stomach of the reclining river god on the right is almost interchangeable with that of St Sebastian, which goes some way to explain this unique detail of posture in the roundel. The ecstatic look of the saint, who throws his head back, has much in common with Mantegna's versions of the subject in Paris (Musée du Louvre). A maiolica plate from Siena depicting Pan playing his pipes (London, British Museum M&LA 1855, 12-1, 114) provides the model for the uniquely splayed legs of the seated saint, a popular feature in sixteenth-century Italian painting which is not associated with St Sebastian. The roundel should also be compared with that of the *Praying Man Beneath a Shrine of the Virgin* (private collection, Baltimore, Maryland), where the unusual splayed-legs posture is repeated and the ground is strewn with rocks in the same way as in the St Sebastian roundel.

Head of the Bound Christ

France, Normandy?

c. 1525–30

44 This head is similar in style to early sixteenth-century glass at the Eglise de Notre-Dame, Caudebec-en-Caux (Seine-Maritime) and the Chapelle du Château at Meillant (Cher) which was constructed for Charles II de Chaumont d'Amboise (d. 1510). The Passion sequence there, usually dated c. 1520, was restored in 1843. Comparison with the Meillant heads shows a similar interest in the flowing locks of hair and thick parted beard of Christ. The fact that Christ does not wear the crown of thorns, and is wearing a shirt, indicates that the head is unlikely to have been the Flagellation scene itself (although the crown of thorns also appears to be absent from the *Flagellation* at Meillant). The anguished look on Christ's face and the remains of a rope round his neck and over his shirt, however, do suggest that the head came from a Passion sequence. In stained glass at the Eglise Saint-Barthélemy, Viry (Saône-et-Loire) Christ is presented as *Ecce Homo* wearing a cloak and bound, but in most images of this type he only wears a loincloth, and it is more likely that the head formed part of a sequence of the arrest of Christ.

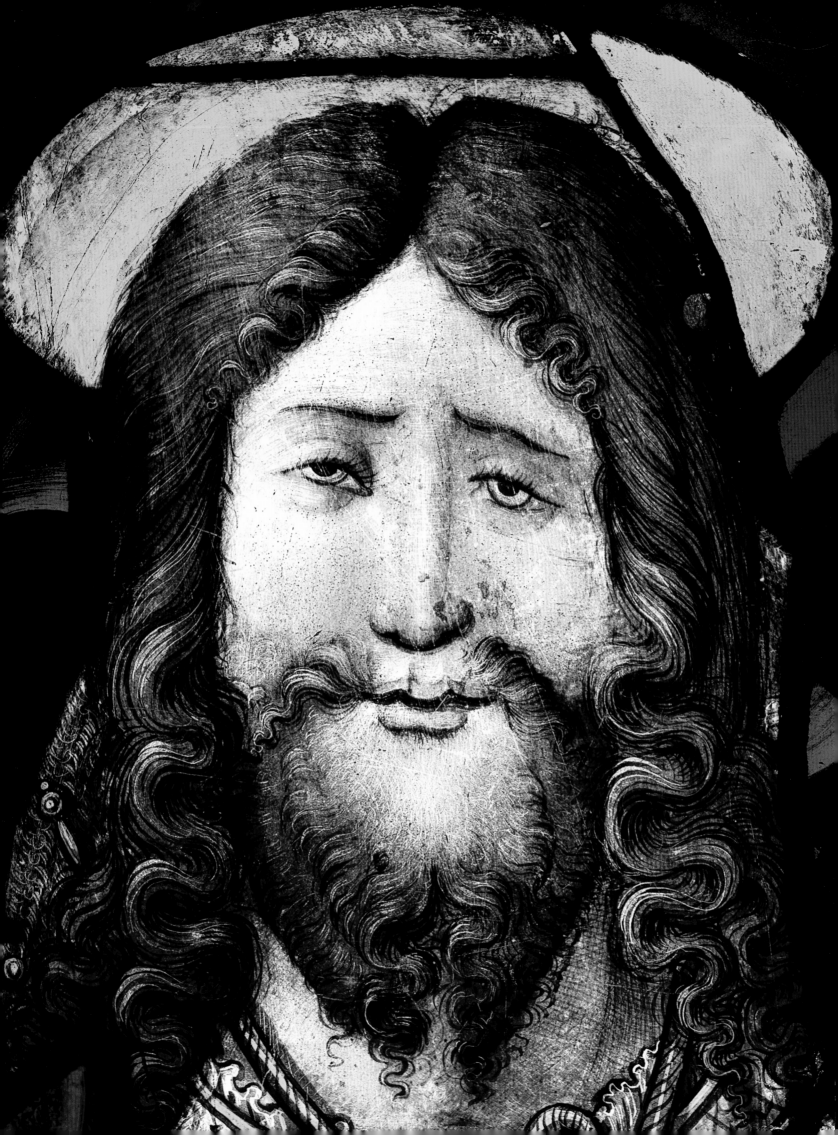

Two Fragments from The
Triumph of Chastity over Love

South Netherlands, Antwerp?
c. 1525–30

45 & 46

These important fragments add considerably to our knowledge of the development of the iconographical theme of the *Triumphs* of Petrarch in Netherlandish glass. Petrarch created a series of poetical allegories in the fourteenth century which were developed with considerable licence by visual artists. What fascinated them most was the idea of the car or chariot (originally only given by Petrarch to Love). Chastity's car becomes drawn by unicorns, in a wonderful adaptation of the medieval bestiary legend that a unicorn can only be tamed by a virgin, and Fame is usually drawn by elephants, while Time has stags. These pieces almost certainly formed part of a single roundel which was broken and then expertly reassembled, probably in the nineteenth century. What makes them unusual is that the composition depends on a frontal rather than a profile view of the chariot of Chastity. The roundels based on this theme produced by both Dirick Vellert and Pieter Coecke van Aelst and his circle in the early sixteenth century use profile arrangements. The closest comparison that can be made for the frontal arrangement found here is with a drawing of the *Triumph of Fame* in Bremen (Kunsthalle), which was probably the model for a lost roundel that was once in the collection of Joan d'Huyvetter of Ghent. The diminutive child at the centre of the Bremen drawing and the two elephants frontally arranged to walk forwards to the left and right towards the spectator, suggest that the fragments here may come from a lost series that has yet to be fully studied. The *Triumphs* were also known in Brussels tapestries and were a particularly popular theme in the Low Countries and England in the early sixteenth century, perhaps because Petrarch's texts were being translated and studied in northern Europe at this time. The beautifully dressed woman in the foreground recalls a similar figure in the foreground of the *Triumph of Chastity* from a set of such tapestries of c. 1507–10 which were bought by Cardinal Wolsey in 1523 from the executors of the Bishop of Durham and are now split between Hampton Court Palace and the Victoria and Albert Museum. The winged cupid, bound and sitting in the middle of the chariot, can be found in both this and the *Triumph of Death over Chastity* (the third of the series).

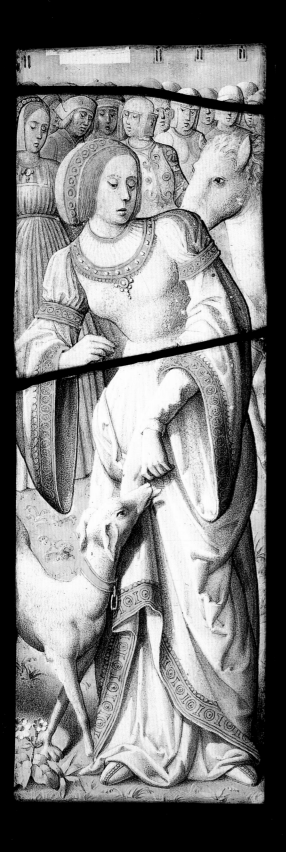

Panel of quarries

England
late 15th and early 16th century

·47

The crowned R monogram probably stands for Richard III (r. 1483–85) and is very close in design to a similar monogram on a panel of quarries now in the Victoria and Albert Museum which has been associated with Westminster Abbey. Of equal interest are what appear to be affronted silkworms tied together with a cord, which may relate to a guild affiliation. Both the R monogram and the IHC monogram for Christ are inserted into this window and probably date to c. 1485. If the interpretation of the cocoons is correct, it is tempting to suggest that the rest of the quarries may belong to a secular light. Such arrangements were popular in the late fifteenth and early sixteenth centuries.

An Emperor or a King

Netherlands
c. 1550

48 This is an unusual survival of what was a popular theme in painting, tapestry weaving and stained glass: the heroes and heroines of the past. Examples of such series in glass roundels survive in Cambridge (King's College Chapel, Window 48), where the heads of two emperors or Caesars and two women are preserved; and a similar but slightly later series, of four emperors and three women, is at Greenville, South Carolina (Bob Jones University, Collection of Sacred Art 753/1A-753/2D). In neither series is the spiked crown and aquiline nose used, but this was popular in south Netherlandish stained glass roundels for all sorts of royal and princely figures in the mid-sixteenth century, for instance in the *Crowning of Nebuchadnezzar*, based on a design by Lambert van Noort of c. 1558 (Cambridge, King's College Chapel, 27, g2). The monumentality of the head and its careful modelling suggest that it should be placed in the 1550s, after the work of Dirck Pietersz at Leiden.

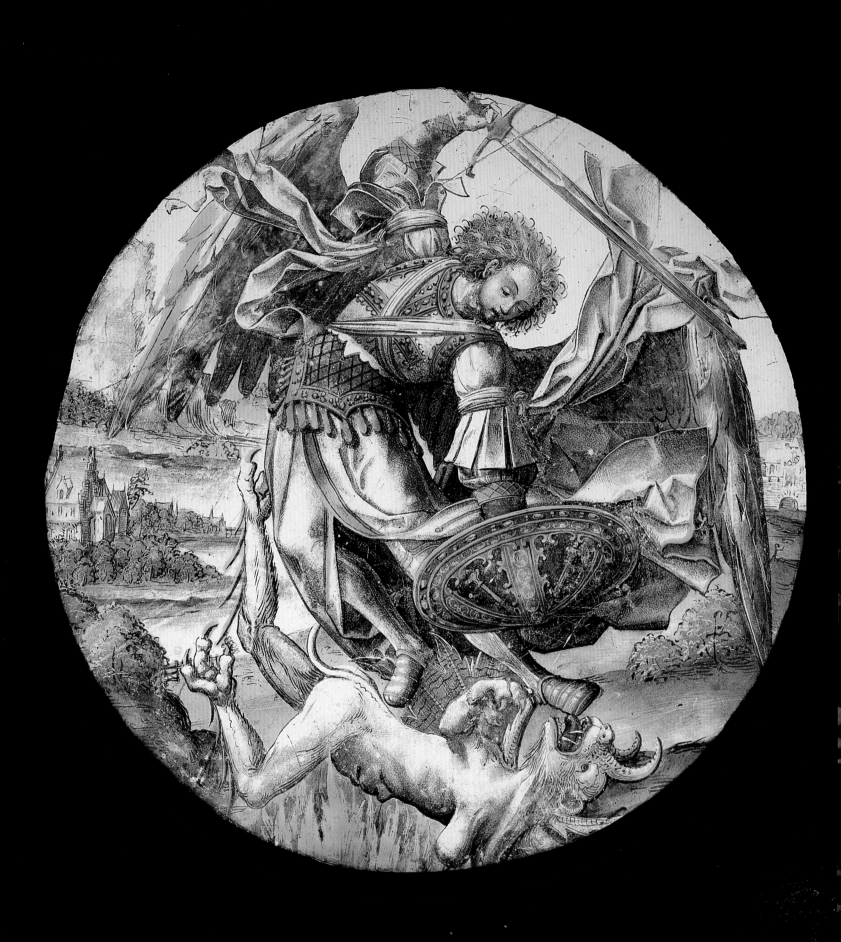

The Archangel Michael

South Netherlands?

c. 1530

49 The bravado of this image, with its agitated drapery and mastery of the silver-stain technique, suggests comparison with two Netherlandish roundels in the Metropolitan Museum of Art: one of *The Fall of the Damned* and the other of *Death Pursuing the Three Tiers of Society*, symbolized by a shepherd, a prince and a pope

(Cloisters Collection, 1990.119.2 and 1977.89 respectively). It also has much in common iconographically with a roundel of St Michael in Corning, New York (Corning Museum of Glass, no. 84.3.236). The drapery which animates the scene is close to that in the Cloisters' Death panel where ridges of cloth form piped folds, although it is less pronounced here. The freedom of the use of silver stain to produce yellow and orange shades, combined with the panoramic views of the countryside, suggest a later date, looking forward to the works of Pieter Coecke van Aelst where such viewpoints are commonplace (e.g. Amsterdam, Rijksmuseum, BK-NM-12570).

Housing the Stranger

North Netherlands
After a print by Dirck Coornhert(?)
based on a design by
Maerten van Heemskerck
c. 1560–70

50 This scene is closely based on one of a set of seven prints of the Works of Mercy after designs by Maerten van Heemskerck (1498–1574). Trained in Haarlem and then Delft, he was one of the first Flemish artists to visit Rome (1532–37) and made countless drawings, many of which he allowed professional engravers to turn into prints. The Seven Works of Mercy – feeding the hungry, giving drink to the thirsty, clothing the naked, visiting the sick, relieving the prisoner, housing the stranger and burying the dead – were often contrasted by preachers with the Seven Deadly Sins as part of a moral framework for good Christian citizens. They were especially popular in stained glass and church furnishings in English parish churches, and two other Flemish panels of the same scene of the late sixteenth century have survived from Addington (Buckinghamshire) and Church Stretton (Shropshire). Despite being damaged and repaired with contemporary glass, this example preserves the full context of the print (including the balcony scene), which is missing from the other examples. The superb quality of the painting suggests comparisons with the series of King Nebuchadnezzar after Lambert van Noort preserved in King's College Chapel, Cambridge and Strawberry Hill (Middlesex).

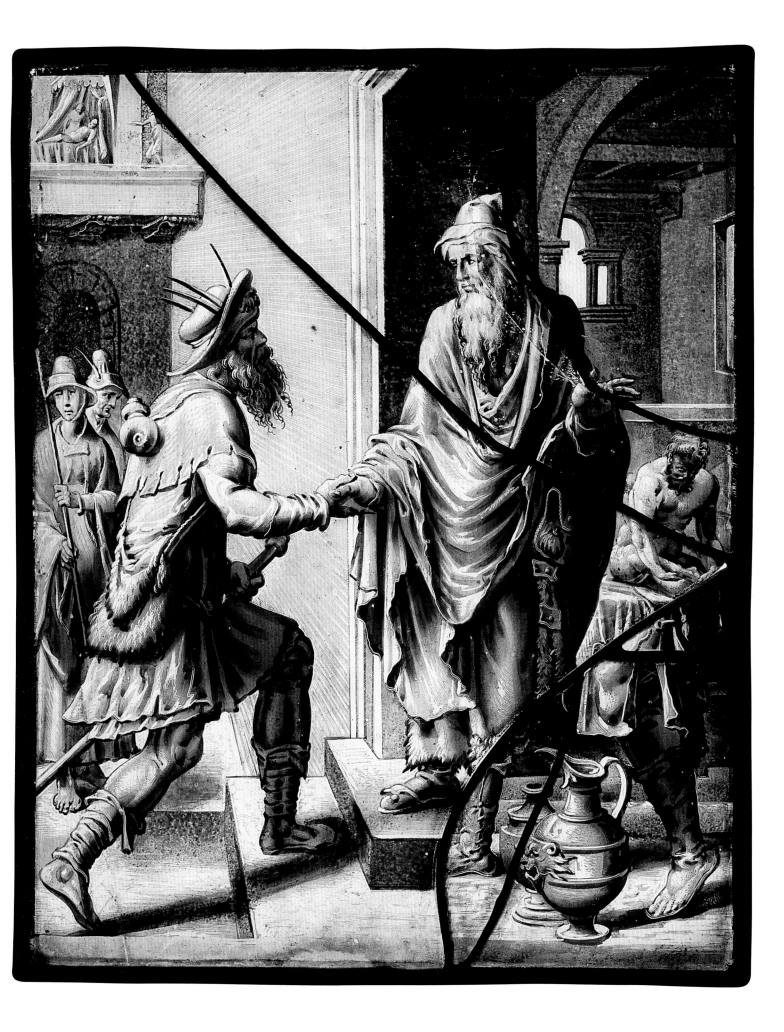

CATALOGUE
with technical descriptions and bibliographies

Key to technical diagrams

Original glass

Old repair, or stopgap using old glass

Modern or nineteenth-century repair

Key to technical diagrams for nos 4 & 5

Medieval glass

Modern glass

1. Composite Roundel
Normandy, Rouen Cathedral?
c. 1210–20 with 14th-century and later insertions
diameter: 381 mm
Inv. no. 8550

Blue, red, green and yellow pot-metal and clear glass with black paint.

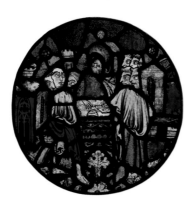

The ensemble includes architectural fragments, foliage and drapery patterns, and four fragments showing faces. The central fragment of clear glass depicts a table with plates and a hand which may come from a separate scene.

LITERATURE
Michael W. Cothern, 'Fragments of an Early Thirteenth-Century St Peter Window from the Cathedral of Rouen', in *Gesta*, vol. 37, 1998, pp. 158–64.
Michael W. Cothern, 'The Seven Sleepers and the Seven Kneelers: Proglomena to the Study of the "Belles Verrières" of the Cathedral of Rouen', in *Gesta*, vol. 25, 1986, pp. 203–26.
Louis Grodecki and Catherine Brisac, *Gothic Stained Glass 1200–1300*, London 1985, cat. 70, pp. 50–52, pl. 39.
Radiance and Reflection: Medieval Art from the Raymond Pitcairn Collection. Catalogue of an Exhibition Held at the Cloisters, The Metropolitan Museum of Art, New York, February 25–September 15, 1982, edited by Jane Hayward and Walter Cahn, nos 56–57, pp. 149–55.
Medieval and Renaissance Stained Glass from New England Collections. Catalogue of an Exhibition Held at the Busch-Reisinger Museum, Harvard University, April 25–June 10, 1978, edited by Madeline H. Caviness, Medford, 1978, no. 5, pp. 17–19.

The Year 1200: A Centennial Exhibition at the Metropolitan Museum of Art, February 12 through May 10, 1970, edited by Konrad Hoffmann, 2 vols, New York 1970, vol. 1, no. 207, p. 202.
J. Lafond, 'La verrière des Sept Dormants d'Ephèse et l'ancienne vitrerie de la cathédrale de Rouen', in *The Year 1200: A Symposium*, New York 1975, pp. 400–416.
Medieval Art from Private Collections. A Special Exhibition at the Cloisters, October 30, 1968, through March 30, 1969, edited by Carmen Gómez-Moreno, New York 1968, nos 183–85.

2. Seraph
France, Reims, Cathedral of Notre-Dame
West Rose
c. 1275–99
350 × 690 mm
Inv. no. 5714-2

Pot-metal yellow, red and blue and clear glass with black paint; some leaded and bonded breaks, surfaces somewhat pitted and corroded; set in a modern border.

Deep blue background. The lower set of wings is blue, the halo is of red glass, and upper parts of the outstretched wings are of yellow glass. The lower part of this pair of wings, the arms, face and the neck scarf, are all of clear glass.

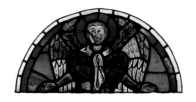

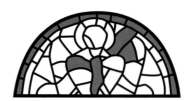

LITERATURE
Virginia Chieffo Raguin and Helen Jackson Zakin with a contribution from Elizabeth Carson Pastan, *Stained Glass Before 1700 in the Collections of the Midwest States*, vol. 2, Michigan – Ohio, *Corpus Vitrearum United States of America, Part VIII*, London and Tounhout, 2001, pp. 15–18.

Anne Prache, Nicole Blondel, et. al., *Les Vitraux de Champagne-Ardennes, Corpus Vitrearum. Série complémentaire, Recensement des vitraux anciens de la France*, vol. IV, Paris 1992, p. 391.
Louis Grodecki and Catherine Brisac, *Gothic Stained Glass 1200–1300*, London 1985, pp. 117–18.

3. Head of a Young Man
France/Belgium, Cambrai-Tournai?
c. 1320–30
diameter: 210 mm
Inv. no. 2803

Blue and red pot-metal and clear glass with silver stain and black paint; some fragments show pitting. All glass is medieval, but composed later.

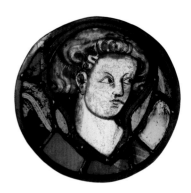

PROVENANCE
1 Collection of Abraham M. Adler (New York).
2 Collection of George A. Douglas (Greenwich, Connecticut).

LITERATURE
Alison Stones, *Le Livre d'images de Madame Marie. Reproduction intégrale du manuscrit Nouvelles acquisitions françaises 16251 de la Bibliothèque Nationale de France*, Paris 1997.
Stained Glass Before 1700 in American Collections: New England and New York (Corpus Vitrearum Checklist I), edited by Madeline H. Caviness and Jane Hayward, *Studies in the History of Art*, vol. 15, Washington 1985, p. 25.
Louis Grodecki and Catherine Brisac, *Gothic Stained Glass 1200–1300*, London 1985, cat. 3, pp. 202–3, pl. 194.

4. Three Figures from the Crucifixion
5. The Crucified Christ
England, St Mary's Meysey Hampton
(Gloucestershire)
c. 1330–40
463 × 310 mm
Inv. nos 6950, 6951

Red, blue, yellow, green and brown pot-metal and clear glass with black paint, washes; glass much pitted and some pigment loss has occurred.

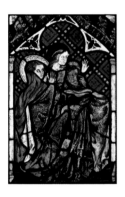

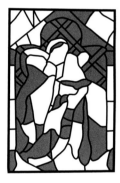

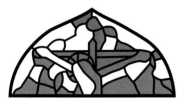

These two panels have both been composed using much fine medieval glass from a Crucifixion scene.

PROVENANCE

Collection of Keith Barley, bought by him from the Church of St Mary, Meysey Hampton (Gloucestershire).

LITERATURE

David Verey and Alan Brooks, *The Buildings of England, Gloucestershire I: The Cotswolds*, 3rd edition, reprinted with corrections, 2000, pp. 473–74.
Michael Archer, Sarah Brown and Peter Cormack, *English Heritage in Stained Glass: Oxford*, Oxford 1987, pp. 67–68.
Lucy Sandler, *Gothic Manuscripts 1285–1385: A Survey of Manuscripts Illuminated in the British Isles*, vol. 5, London 1986, no. 117, pp. 130–31.

6. The Virgin and Child
Austria, Cistercian Abbey of Klosterneuburg
Master of Klosterneuburg
c. 1335
diameter: 359 mm
Inv. no. 7396

Red, blue, green and purple pot-metal and clear glass, with black paint and silver stain; inscription on reverse of Virgin's halo: 'gemacht 1234', '[…] über monsl. 1837 von […]' in a nineteenth-century copper-plate hand.

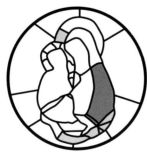

The Virgin is dressed in a light green tunic and a purple mantle edged with blue (partly restored); she holds the Christ child dressed in red. The Virgin's scalloped halo is in yellow and Christ's cross nimbus is picked out in lime green (the separately leaded cross uses a complementary yellow).

PROVENANCE

Collection of E. and M. Kofler-Truninger, 1955

LITERATURE

Himmelslicht. Europäische Glasmalerei im Jahrundert des Kölner Dombaus (1248–1349), Cologne 1998, pp. 292–93, no. 74.
Louis Grodecki and Catherine Brisac, *Gothic Stained Glass 1200–1300*, London 1985, cat. 9, pp. 221–22.
Eva Frodl-Kraft, *Die Mittlealterlichen Glasgemälde in Niederösterreich*, vol. 1, Vienna 1972, p. 199, fig. 630.
Sale catalogue, *Kende Auktionhaus*, Vienna, 24–27 April 1951, no. 177.

7. Two Music-Making Angels
France, Rouen Cathedral?
c. 1340–50
75 × 150 mm
Inv. no. 4581

Silver stain and black paint on clear glass, set in modern clear glass with a blue border; some scratching on both surfaces, both considerably eroded at edges.

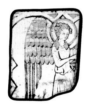

The angels confront each other within fragmentary quatrefoil borders; one blows a trumpet, the other may originally have played an organ.

LITERATURE

Himmelslicht. Europäische Glasmalerei im Jahrundert des Kölner Dombaus (1248–1349), Cologne 1998, pp. 273–75, no. 66, pls 1–3.
Elisabeth Taburet-Delahaye, 'Moyen Age: vitrail', *Musée du Louvre, Nouvelles acquisitions du département des Objets d'art 1985–1989*, Paris 1990, nos 35a–c, pp. 75–76.
Nicole Blondel, Louis Grodecki, Françoise Perrot and Jean Taralon, *Les vitraux du Centre et des Pays de la Loire, Corpus Vitrearum. Série complémentaire, Recensement des vitraux anciens de la France*, vol. 2, Paris 1981, p. 204, plate XI.

Jean Lafond (with F. Perrot and P. Popescu), *Les vitraux du choeur de Saint-Ouen, Rouen, Corpus Vitrearum, France*, IV–2/1, Paris 1970.
Vitraux de France du XIe au XVIe siècle, Musée des Arts Décoratifs, Mai–Octobre 1953, edited by Louis Grodecki and Jean Lafond, Paris 1953, no. 32, p. 70.

8. Head of an Angel or Saint
France, Bourges?
c. 1410
470 × 470 mm
Inv. no. 6476-1

Blue, red and green pot-metal and clear glass with silver stain and brown paint; surfaces somewhat abraded.

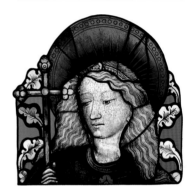

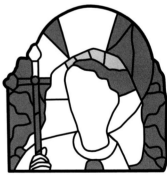

The figure holds a cross and the face is framed by modern yellow and green oak leaves. The face is enclosed by thick wavy fair hair crowned with a diadem. The figure wears a dark blue tunic with an orange collar. The head would originally have been part of a much larger panel.

LITERATURE

Brigitte Kurmann-Schwarz, 'Les verrières à Bourges dans la première moitié du XVe siècle et leurs modèles: tradition et renouveau', in *Vitrail et Arts Graphiques XVe–XVIe siècles. Les cahiers de l'Ecole nationale du patrimoine*, vol. 4, *Table ronde coordonnée par Michel Hérold*, Paris 1999, pp. 137–49.

Nicole Blondel, Louis Grodecki, Françoise Perrot and Jean Taralon, *Les vitraux du Centre et des Pays de la Loire, Corpus Vitrearum. Série complémentaire, Recensement des vitraux anciens de la France*, vol. 2, Paris 1981, p. 181.

Marcel Aubert, et al., *Le Vitrail français*, Paris 1958, p. 174.

9. The Virgin and St John from a Crucifixion
Germany, Erfurt?
c. 1420
585 × 500 mm
Inv. no. 7614

Pot-metal blue, red and green glass, clear glass with silver stain and black paint; surfaces somewhat worn.

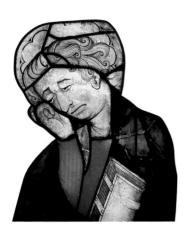

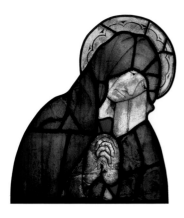

The Virgin is dressed in a blue mantle and red tunic and has a cusped silver-stained halo. St John is dressed in a green mantle and tunic; he has a silver-stained book and hair and a cusped clear glass halo.

LITERATURE
Virginia Chieffo Raguin and Helen Jackson Zakin with a contribution from Elizabeth Carson Pastan, *Stained Glass Before 1700 in the Collections of the Midwest States,* vol. 1, Illinois, Indiana, Michigan, Ohio, *Corpus Vitrearum United States of America, Part VIII*, London and Tounhout, 2001, pp. 169–75.
Falko Bornschein, Ulrike Brinkmann and Ivo Rauch, *Erfurt, Köln, Oppenheim. Quellen und Studien zur Restaurierungs-geschichte mittelalterlicher farbver-glasungen*, introduction by Rüdiger Becksmann, Berlin 1996, p. 74.
Erhard Drachenberg, *Die Mittelalterliche Glasmalerei im Erfurter Doms, Corpus Vitrearum Medii Aevi, Deutschland*, vol. 15, 2 vols, Berlin 1980–83 (originally published as DDR 1.2).
Houston Museum of Fine Arts, Six Master Paintings, Two Glasses, One Sculpture, March 20–April 21, 1963, Houston 1963, unnumbered (reproduced on front and back cover).

10. St Margaret
Germany, Cologne?
c. 1420–30
710 × 435 mm
Inv. no. 4254

Clear glass and blue, green, red, brown and purple pot-metal with silver stain and black paint, stipple shading.

St Margaret wears a delicately patterned tunic and a white mantle. Her hair is long and golden. With one hand Margaret indicates a crested coat of arms, in the other she loosely holds a cross and a chain. The chain is attached to the collar of a dragon – the attribute of St Margaret – which sits at her feet. She stands within a windowed niche with a chequered floor. Through a window is a garden with flowers. The armorial (Per pale gules and argent) may relate to the im Thurn family.

EXHIBITED
Vor Stefan Lochner. Die Kölner Maler von 1300 bis 1430, Wallraf-Richartz-Museum, 29th March–7th July 1974, Cologne 1974, no. 66.

LITERATURE
Brigitte Corley, *Conrad von Soest: Painter Among Merchant Princes*, London 1996, p. 255, n. 39.
Claus Reisinger, *Flandern in Ulm. Glasmalerei und Buchmalerei die Verglasung der Bessererkapelle am Ulmer Münster*, Worms 1985, pp. 208–9.
Herbert Rode, 'Colloquium zur Kölner Glasmalerei', in *Vor Stefan Lochner Die Kölner Maler von 1300 bis 1430 Ergebnisse der Ausstellung und des Colloquiums, Köln 1974, Begleithefte zum Wallraf-Richartz-Jahrbuch 1977*, vol. 1, edited by Gerhard Bott, p. 101, fig. 6.
Jane Hayward, 'Stained Glass of the Middle Ages and Renaissance', in *Metropolitan Museum of Art Bulletin*, 30, 1971–72, pp. 98–152.
Herbert Rode, *Die mittelalterlichen Glasmalerein des Kölner Domes, Corpus Vitrearum Medii Aevi, Deutschlands*, vol. IV, 1, Berlin 1974, p. 173, no. 7.
Grosse Kunstauktion in Luzern, Galerie Fischer Luzern, Luzern 1970, cat. 570, fig. 570.
Herman Schmitz, *Die Glasgemälde des königlichen Kunstgewerbemuseum in Berlin*, Berlin 1913, p. 43.

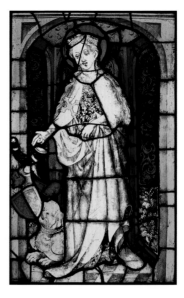

11. St John the Evangelist
Germany, Ulm?
c. 1430
626 × 316 mm
Inv. no. 3934

Clear glass and blue and brown pot-metal with black paint and silver stain; some pitting and paint loss, a number of breaks; some minor replacements.

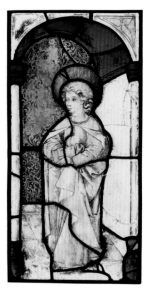

St John stands within an arched stone niche on a tiled floor wearing a cloak over a buttoned tunic, facing left and holding the gospel against a blue glass background decorated with scrolling foliage. The arch spandrels are decorated with trefoils.

LITERATURE
Claus Reisinger, *Flandern in Ulm. Glasmalerei und Buchmalerei die Verglasung der Bessererkapelle am Ulmer Münster*, Worms 1985.
Herbert Rode, *Die mittelalterlichen Glasmalerein des Kölner Domes, Corpus Vitrearum Medii Aevi, Deutschland*, vol. IV, 1, Berlin 1974.
Hans Wentzel, *Meisterwerke de Glasmalerei*, Berlin 1951, pl. 199.

12. The Lion of St Mark
England
c. 1420–30
diameter: 322 mm
Inv. no. 7546

Blue pot-metal and clear glass with silver stain and black paint, stipple shading with abraded highlights; some pitting.

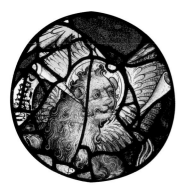

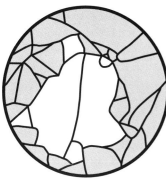

The head and halo of the lion are painted on the same piece of glass. The inscription is made up of different pieces of contemporary glass, probably from the same window.

LITERATURE

Thomas French, *Corpus Vitrearum Medii Aevi, Great Britain, Summary Catalogue 2, York Minster, The Great East Window*, Oxford 1995.
Richard Marks, *Stained Glass in England During the Middle Ages*, London 1993, pp. 180–89, p. 199.

13. and 14. Two Angels
England. Midlands?
c. 1420–30
149×90 mm. 145×90 mm
Inv. no. 5515

Clear glass with silver stain and brown paint; set in modern clear glass.

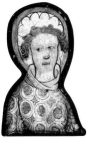

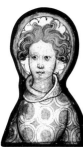

Two half-length, haloed figures. Each wears liturgical dress: an amice around the neck and an alb patterned with silver-stained yellow flowers.

LITERATURE

Peter Newton with the assistance of Jill Kerr, *Corpus Vitrearum Medii Aevi Great Britain, Volume 1, The County of Oxford, A Catalogue of Medieval Stained Glass*, London 1979, p. 58, pl. 21d.
Richard Marks, 'Window Glass', in *English Medieval Industries: Craftsmen, Techniques, Products*, edited by John Blair and Nigel Ramsey, London 1991, pp. 265–94, fig. 137.

15. Kneeling Donor
France. Brittany
c. 1440–50
749×351 mm
Inv. no. 8354

Clear glass and blue pot-metal with black paint, traces of silver stain; considerable pitting. Some minor replacements; upper canopy imported.

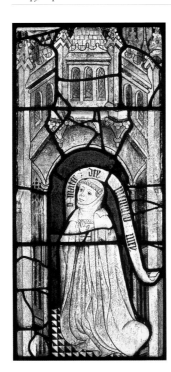

Female donor kneeling on a checked floor against a blue background, surrounded by an architectural canopy. She holds a scroll inscribed in *textus semi quadratus*: *O mater: dey memento: mey* ['O mother of God remember me']. The canopy and replacements belonged to another window in the same church.

LITERATURE

Virginia Chieffo Raguin and Helen Jackson Zakin with a contribution from Elizabeth Carson Pastan, *Stained Glass Before 1700 in the Collections of the Midwest States*, vol. 2, Michigan – Ohio, *Corpus Vitrearum United States of America, Part VIII*, London and Tounhout, 2001, pp. 142–44.
George Wigley, 'Tales from the Auction Rooms', in *Journal of Stained Glass*, vol. 24, 2000, p. 141.
Sotheby's sale. *European Sculpture and Works of Art*, Amsterdam, 19 December 2000, lot 322.
Roland Sanfaçon, 'L'Arbre de Jessé réinventé dans le vitrail en France vers 1445–1450: le témoignage de quatre panneaux conservés à Québec', in *Gesta*, 37, 1998, pp. 251–57.

16. The Resurrected Christ Blessing
England, Norfolk?
c. 1450–70
186×153 mm
Inv. no. 7365

Clear glass with silver stain and dark brown paint, set in a border of modern clear glass.

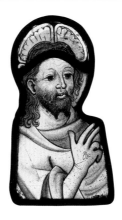

Christ's hair, beard and halo all stained yellow.

LITERATURE

Richard Marks, *Stained Glass in England During the Middle Ages*, London 1993, p. 199, fig. 168, note 22.
David J. King, *Stained Glass Tours Around Norfolk Churches*, Woodbridge 1974, p. 9.
William Wells, *Figure and Ornamental Subjects: Stained and Painted Glass: Burrell Collection*, Glasgow 1965, p. 26, cat. 72.

17. Female Head
England?
c. 1400
154×119 mm
Inv. no. 8462

Clear glass with silver stain and black paint with stipple shading, set in a border of modern clear glass.

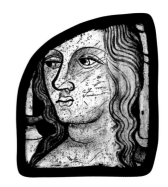

A fragmentary head with silver-stained hair is placed between two shafts. Upon the shafts are mouldings.

LITERATURE

John Baker, Herbert Read and Alfred Lammer, *English Stained Glass*, London 1960, p. 108.
Francis C. Eeeles and A.V. Peatling, *Ancient Stained and Painted Glass in the Churches of Surrey*, Guildford, 1930, pp. 52 and p. 97, pl. 2.

18. Ensemble with Lute-Playing Angel
England (larger pieces) and South Netherlands (fragments)
c. 1450 and 1553
330×279 mm
Inv. no. 7832-1

Brown paint and silver stain on clear glass with stipple shading; modern amber and red inserts.

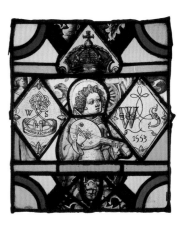

The central panel of a lute-playing angel with plectrum is set into fragments of Flemish glass depicting a partially draped figure below a wheel, and an eagle (probably heraldic). The two quarries are similarly set against a Flemish fragment of a woman's head and a fragment of the embellishment of a shield. The crown above and the leafy man's head below are set against fragments of silver-stained and black leaves. This suggests the framing of a lost shield in the centre. The modern amber and red quarter circles and bands appear to have been added later. The two monogrammed quarries form part of a separate ensemble. They both bear the initials w.s., and the left-hand quarry bears the motto *confide recte agens* [trust in doing right]. The right-hand quarry also bears the date 1553.

LITERATURE

Richard Marks, *Stained Glass in England During the Middle Ages*, London 1993, pp. 188–89, fig. 80 and fig. 157.

19. The Apostles Thomas and Philip
Germany, Cologne?
c. 1460–70
Each 470 × 222 mm
Inv. no. 7355

Red pot-metal and clear glass, silver stain and brown paint, stipple shading with picked-out highlights and back painting; the framing red glass is modern.

LITERATURE

Brigitte Corley, *Painting and Patronage in Cologne 1300–1500*, London 2000, pp. 133–68.
Brigitte Lymant, *Die Glasmalereinen des Schnütgen-Museums, Bestandskatalog*, Cologne 1982, p. 129, no. 72.

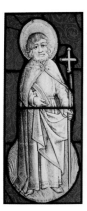 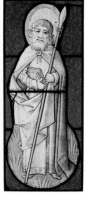

20. Head of a Woman (St Anne?)
England, Norwich?
c. 1480
310 × 260 mm
Inv. no. 7368

Clear glass with black painting and stipple shading, traces of background silver stain; set in a modern border of clear glass.

Head of a woman wearing an ermine-trimmed headdress and veil.

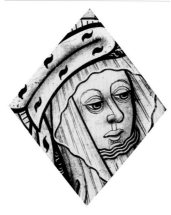

LITERATURE

Richard Marks, *Corpus Vitrearum Medii Aevi, Great Britain, Summary Catalogue 4, The Medieval Stained Glass of Northamptonshire*, Oxford 1998, pp. 275–76.
Richard Marks, *Stained Glass in England During the Middle Ages*, London 1993, p. 198, fig. 167.
John Baker, Herbert Read and Alfred Lammer, *English Stained Glass*, London 1960, pls 3, 24–25 and 61–62.
Christopher Woodforde, *The Norwich School of Glass-Painting in the Fifteenth Century*, London 1950, pp. 42–54.

21. Heraldic Panel showing the Eberler (gennant Grünenzweig) Family Arms
Switzerland, Basel?
Circle of the Housebook Master (Master of the Amsterdam Cabinet)
c. 1480–90
310 × 440 mm
Inv. no. 5853

Violet, red, blue and green flashed glass (red and blue abraded); framing border is of clear glass, with black vitreous paint and silver stain; a small replacement piece in the upper section; in excellent overall condition; the leading is probably nineteenth century.

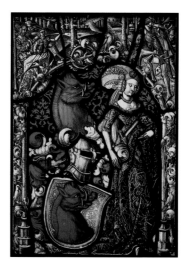

In the central field: Against a purple and black patterned velvet background, on the right, a courtly lady stands wearing a blue 'chiselled' silk-velvet gown with ample skirts and short sleeves; the undergown is cloth of gold. She wears a golden choker-necklace, long kid gloves and a diagonally-worn gold belt with a dagger fastened to it. She gazes down to her left, her hair covered by an elaborate, patterned headdress apart from blond ringlets on either side of the face. A silk veil hangs down from the back of her head. Her right arm is placed over the mantling of the armorial and crest of the Eberler arms, and her left holds up the train of her gown. The whole scene beneath an arboured archway inhabited by birds, including hoopoe and woodpecker. The spandrels: Occupied with a scene of falconry in a clearing in front of a wood with a castle in the distance; executed in silver stain, red enamel and grisaille. On the left: A group of two courtly women and a page. The women wear over-gowns in black cloth of gold (left) and white with a red cloth

of gold undergown (right) and elaborate headdresses and cape-like collars. The page wears a doublet, striped hose and hat. The woman in the foreground has a hawk on her right hand as she waves bait with her left and looks up at a woodpecker chased by a hawk. The woman on the left holds another hawk, while the page offers his hand. On the right: A young man with long curly blond hair, flat hat and a large dagger, wearing striped hose, with a bag of bait round his waist, waves at the ladies on the left with his right hand while carrying a hawk on his left. Behind are two other hunters wearing hats, one with short yellow curly hair. His greyhound is immediately in front of him to the right (obscured by a medieval repair of another greyhound and running man). In front of him in the background a small building can be seen.

ARMS Shield; Or a boar's head sinister gules (Eberler gennant Grünenzweig).
CREST On a tilting helm a boar's head to sinister gules, mantling of the colours.

PROVENANCE
Private collection, France.

LITERATURE
Painting on Light: Drawings and Stained Glass in the Age of Dürer and Holbein, edited by Barbara Butts and Lee Hendrix with Scott C. Wolf, Los Angeles 2000, pp. 68–74.
Timothy B. Husband, *The Medieval Housebook and the Art of Illustration*, New York 1999, p. 72, fig. 28.
Timothy B. Husband, 'The dissemination of design in small-scale glass production: the case of the "medieval housebook"', in *Gesta*, vol. 37, 1998, pp. 178–85.
Rüdger Becksmann, *Deutsche Glas-malerei des Mittelalters. Voraussetzungen Entwicklungen Zusammenhänge*, 2 vols, Berlin 1991–95, vol. 1, no. 64.
Livelier than Life: The Master of the Amsterdam Cabinet or the Housebook Master, ca. 1470–1500, Exhibition held at the Rijksmuseum Amsterdam, edited by Jan Piet Filedt Kok, et. al., 1985, nos 23, 84, 135 and 136.
Rüdger Becksman, '"Das Hausbuchmeisterproblem" in der Mittelrheinischen glasmalerei', in *Pantheon*, vol. 26, 1968, pp. 352–67.

August Burckhardt, 'Die Erberler genannt Grünenzweig', in *Basler Zeitschrift für Geschichte und Altertumskunde*, vol. 4, 1905, pp. 246–76.

22. Fragment (from the Martyrdom of the Ten Thousand?)
South Netherlands, Ghent?
Hugo van der Goes group
c. 1480–90
120 × 94 mm
Inv. no. 7759

Clear glass with black paint and silver stain, stipple shading with picked-out highlights, back painting.

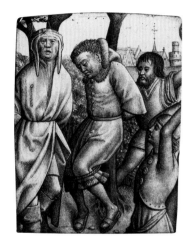

Two men stand tied to trees, on the left a man with a cap and fur-lined overmantle, on the right a man in a hood and fur-lined buttoned and belted coat, wearing clogs. A man in a fictive three-buttoned garment raises his hands, and a man in tightly fitting V-necked garment also brings his arm up. Beyond a bush, a view of a gabled house, tower and church with weathervane.

LITERATURE
Pieter C. Ritsema van Eck, *Gebrandschilderde ruitjes uit de Nederlanden, Painted glass roundels from the Netherlands, 1480–1560*, Zwolle 1999, pp. 10–13, no. 3.
Elizabeth Dhanens, *Hugo van der Goes*, Antwerp 1998, p. 100.
Timothy B. Husband, *The Luminous Image: Painted Glass Roundels in the Lowlands 1480–1560*, New York 1995, pp. 50–67, esp. p. 54 and no. 5.
James Byam Shaw, *Drawings by Old Masters at Christ Church Oxford*, vol. 1, 1976, p. 320, pl. 772.

Dürer in America: His Graphic Work, edited by Charles W. Talbot, New York and London 1971, p. 162, no. 82.

23. The Crowned Virgin and Child as the 'Apocalyptic Woman Clothed in the Sun'
Germany, Middle Rhine?
Late 15th century
diameter: 200 mm
Inv. no. 4582

Clear glass with silver stain and black paint; stipple shading.

PROVENANCE
Chateau d'Anet (Eure-et-Loire).

LITERATURE
Timothy B. Husband, *The Medieval Housebook and the Art of Illustration*, New York 1999, p. 72, fig. 28.
Stained Glass before 1700 in American Collections: New England and New York (Corpus Vitrearum Checklist I), edited by Madeline H. Caviness and Jane Hayward, *Studies in the History of Art*, vol. 15, Washington 1985, p. 127.
Nicole Blondel, Louis Grodecki, Françoise Perrot and Jean Taralon, *Les vitraux du Centre et des Pays de la Loire, Corpus Vitrearum. Série complémentaire, Recensement des vitraux anciens de la France*, vol. 2, Paris 1981, pp. 21–22.

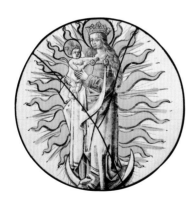

24. Christ on the Mount of Olives
Netherlands
c. 1480–1500
diameter: 272 mm
Inv. no. 7057

Clear glass with silver stain, stipple shading in a pinkish brown paint, picked-out highlights and back painting; modern red glass border.

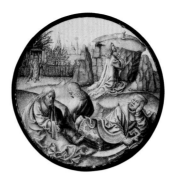

Christ prays by a rocky outcrop in the middle ground. In the background the sun rises over Jerusalem, shown behind a wattle fence. On the right Judas and a band of soldiers enter the enclosure. In the foreground Peter is shown lying full-length, sleeping with one hand on his head. James sits with his hands together in prayer, his eyes closed. John sits with his back to us.

LITERATURE
Landmarks in Print Collecting: Connoisseurs and Donors at the British Museum since 1753, edited by Antony Griffiths, London 1996, p. 101, no. 34.
Timothy B. Husband, *The Luminous Image: Painted Glass Roundels in the Lowlands 1480–1560*, New York 1995, p. 72, no. 18.
William Cole, *A Catalogue of Netherlandish and North European Roundels in Britain, Corpus Vitrearum Medii Aevi, Great Britain, Summary Catalogue*, London 1993, p. 110, no. 8

25. The Virgin and Child with St Joseph, and St John the Evangelist and a Prophet or Elder
South Netherlands, Bruges?
c. 1490
205 × 113 mm, 250 × 113 mm, 205 × 113 mm
Inv. no. 3676

Clear glass with silver stain (mid-yellow to orange), painted in brown, with stipple shading, highlights picked out. The lower half of the Virgin and Child with St Joseph is a modern replacement.

1 Figure of a prophet or elder standing on plinth, holding a scroll in his right hand and with his left held to his chest, wearing an elaborately decorated mantle with scalloped lower edge and ermine-lined sleeve, his head covered with a head-cloth, set in front of an architectural backdrop.

2 Virgin and Child with St Joseph: half-length Virgin holding the Christ child with cross halo looking to the left. St Joseph is shown with a stick emerging from behind the right of the Virgin; the star is shown above the three figures.
3 St John the Evangelist standing on a plinth holding a book in his left hand and a quill pen in his right, in yellow robe and white mantle, an eagle at his feet, in front of an architectural setting.

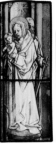

LITERATURE
Maryan W. Ainsworth, *Gerard David: Purity of Vision in an Age of Transition*, New York 1998 p. 102.
Timothy B. Husband, *The Luminous Image: Painted Glass Roundels in the Lowlands 1480–1560*, New York 1995, pp. 70–71, nos 16–17.
Dirk De Vos, *Hans Memling: The Complete Works*, London 1994, p. 186, cat. 4.

26. The Crucifixion
South Netherlands
1490–1500
diameter: 347 mm
Inv. no. 7051

Red and blue pot-metal glass, clear glass with silver stain, black and brown paint with stipple shading, highlights picked out; one border panel a modern replacement.

The cross is set on a brown hill in the foreground with the skull and bones of Adam at its foot. The Virgin and St John are painted in grisaille with silver-stained yellow haloes. The hair and edging of St John's cloak are also silver-stained, as is the halo, crown of thorns and cross. The landscape is painted in shades of brown and yellow with a grisaille townscape beyond a gate in the middle ground. The border is of clear glass with silver-stained yellow and white flowers interspersed with blue and red pot-metal glass.

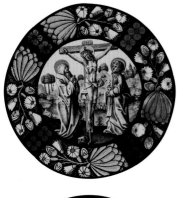

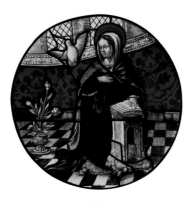

LITERATURE
Timothy B. Husband, *The Luminous Image: Painted Glass Roundels in the Lowlands 1480–1560*, New York 1995, p. 57, nos 8–9.
William Wells, *Figure and Ornamental Subjects: Stained and Painted Glass: Burrell Collection*, Glasgow 1965, p. 48, no. 173.

27. The Virgin Annunciate
Italy, Florence
Domenico Bigordi, called Ghirlandaio, and his workshop
c. 1491
diameter: 592 mm
Inv. no. 4324

Clear glass and blue and red pot-metal with black paint and silver stain, stipple shading.

The window is substantially original (see diagram), with all the old glass showing signs of the use of a grozing iron to nibble the edge of the glass into shape.

LITERATURE
Jean K. Cadogan, *Domenico Ghirlandaio: Artist and Artisan*, New Haven and London 2000, p. 167, cat. 88.
Michael Jaffé, *The Devonshire Collection of Italian Drawings: Tuscan and Umbrian Schools*, London 1994, pp. 62–3.

Anne Prache, Nicole Blondel, et. al. *Les Vitraux de Champagne-Ardennes, Corpus Vitrearum. Série complémentaire, Recensement des vitraux anciens de la France.* vol. IV, Paris 1992, p. 418.

28. The Crucifixion with St Christopher and a Donor
France, Lorraine/Burgundy
Jacot de Toul?
c. 1500–1510
Two lights each: 2250 × 640 mm
Inv. no. 5810

4 panels (top panels 980 × 640, base panels 1270 × 640 mm) with wooden frames; silver stain and black paint on pot-metal (blue, green, brown and red) and white enamel and clear glass, stipple shading; abraded and silver-stained flashed ruby and silver-stained pot-metal blue glass (changing to green where stained).

1 The Crucifixion flanked by the Virgin and St John. Christ's blood is collected in chalices from his hands by flying angels painted in grisaille and in a chalice at the foot of the cross. St John, dressed in a white tunic with silver-stained decorative borders at the neck, cuffs and hem, interleaves the fingers of his hands as he looks up at Christ with tears running down his cheeks. His mantle

is deep red. The Virgin wears a white veil and a blue mantle, with a green lining. Her hands are crossed over her heart as tears roll down her cheeks. All three figures have ruby flashed-glass haloes edged with silver stain and a ring of clear abraded-glass circles. The skull of Adam is at the foot of the cross.

2 St Christopher wades across the river gripping a long staff in his right hand, the Christ child on his shoulders blessing with his right hand and in his left holding an orb that trails a flag of victory in red with a cross picked out in white enamel. St Christopher introduces the donor by gesturing with his flat open hand behind his head as he kneels at a prie-dieu with prayer book. He wears armour consisting of a coat of mail with a heraldic tabard, a vambrace covering his lower arm, a winged couter at the left elbow, cuisses and greaves on his legs with winged

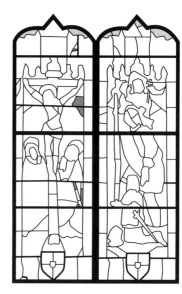

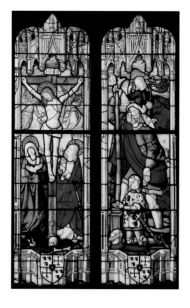

poleyns at the joints. He also wears a sword in a mauve scabbard with gilded decoration at the side. His helmet, a gold-inlaid close-helm, stands on the ground. Both scenes are bordered with silver-stained gothic architectural canopies with pinnacles and music-making angels. The armorials on shields at the foot of the panels and on the tabard of the donor: quarterly 1st and 4th argent, three wolves heads couped sable, 2nd and 3rd argent a cross moline sable between three escallops or; in pretence an escutcheon azure, charged with a fleur-de-lis or.

LITERATURE
Michel Hérold, *Les Vitraux de Saint-Nicolas de Port, Corpus Vitrearum, France VIII, I*, Paris 1993, p. 32.
Michel Hérold and Françoise Gatouillat, *Les Vitraux de Lorraine et d'Alsace, Corpus Vitrearum, France*, Paris 1994.
Martine Callias-Bey, Véronique Chaussé, Laurence de Finance, et al., *Les Vitraux de Bourgogne, Franche-Comté et Rhône-Alpes, Corpus Vitrearum. Série complémentaire, Recensement des vitraux anciens de la France*, vol. III, Paris 1986, p. 23.

29. A Bishop Saint
France?
c. 1500
388 × 328 mm
Inv. no. 7054

Blue pot-metal and clear glass with silver stain, stipple shading in a pinkish brown paint, back painting. Blue glass and top of crozier, although medieval glass, seem not to belong with the bishop figure.

The bishop wears a chasuble and a jewelled mitre and he holds a crozier and an open book.

LITERATURE
Nicole Blondel, Louis Grodecki, Françoise Perrot and Jean Taralon, *Les vitraux du Centre et des Pays de la Loire, Corpus Vitrearum. Série complémentaire, Recensement des vitraux anciens de la France*, vol. 2, Paris 1981, p. 267, fig. 248.
David Bomford and Jo Kirby, 'Two Panels by the Master of Saint Giles', in *National Gallery Technical Bulletin*, vol. I, 1977, pp. 49–56.

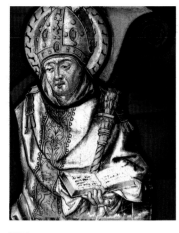

William M. Hinkle, 'The Iconography of the Four Panels by the Master of Saint Giles', in *Journal of the Warburg and Courtauld Institutes*, vol. 28, 1965, pp. 110–44.
Grete Ring, *A Century of French Painting 1400–1500*, London 1949, pls 135–36, cat. 239.

30. St Bernard
Germany, Cologne?
c. 1500
diameter: 232 mm
Inv. no. 3676

Clear glass with silver stain, black paint, stipple shading and picked-out highlights.

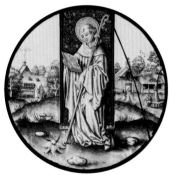

St Bernard stands on a hillock and in front of a black and gold brocaded cloth of honour. He wears a distinctive pale habit (usually white) and carries a gilt crozier in his left hand while reading from an open book held in his right hand. In the background a group of buildings with a smoking chimney (on the left) which includes a hutch (for rabbits?). A monk with a staff is seated on the right in front of a tree with a small roofed shrine attached to it. The buildings on the right include a dovecote and a gabled protective roof over the image of the Crucifixion that guards the doorway into an enclosure.

LITERATURE
Timothy B. Husband, *Stained Glass before 1700 in American Collections: Silver-Stained Roundels and Unipartite Panels (Corpus Vitrearum Checklist IV)*, Baltimore 1991, p. 96.
Brigitte Lymant, *Die Glasmalereinen des Schnütgen-Museums, Bestandskatalog*, Cologne 1982, p. 163, no. 93c.
Herbst des Mittelalters. Spatgotik in Köln und am Niederrhein, exhibition Köln Kunsthalle, edited by Gert von der Osten, Cologne 1970, p. 73.

31. Rest on the Flight into Egypt
South Netherlands, Bruges?
c. 1510
diameter: 220 mm
Inv. no. 3674

Clear glass with silver stain, brown and black paint with picked-out highlights and back painting.

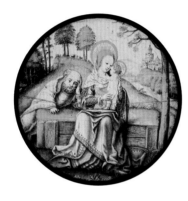

The Virgin sits on a grassy bench, holding on her lap the standing, naked Christ child, who plays with her veil. She wears a richly patterned gown and a cloak with embroidered hem. Joseph is seated on the ground behind the bank in a tunic and cloak. A hill with trees rises up behind them and a river runs to the right, with the towers of a town in the distance.

LITERATURE
Bruges and the Renaissance: Memling to Pourbus, edited by Maximiliaan P.J. Martens, Ludion 1998, pp. 120–22, figs 45–47.
Timothy B. Husband, *The Luminous Image: Painted Glass Roundels in the Lowlands 1480–1560*, New York 1995, pp. 70–71, nos 16–17.
German Renaissance Prints 1490–1550, edited by Giulia Bartrum, London 1995, p. 28, no. 11.

32. Heraldic Roundel with the arms of Ebra (gennant Pfaff)?
Germany, Augsburg?
c. 1480–90
diameter: 257 mm
Inv. no. 3328

Pot-metal flashed blue glass with silver stain, clear glass with silver stain and black paint.

ARMS Azure per bend sinister a ladder or.
CREST On a tilting helm to dexter a pair of wings of the first charged as the field; mantling of the colours.
The arms are probably those of Ebra gennant Pfaff, of Prussia and Saxony.

PROVENANCE
Collection of Jane Hayward, New York.

LITERATURE
Sotheby's sale, *European Works of Art, Arms and Armor, Furniture and Tapestries*, New York, 31 January 1997.
Stained Glass Before 1700 in American Collections: Midwestern and Western States (Corpus Vitrearum Checklist III), edited by Michael W. Cothren, *Studies in the History of Art*, vol. 28, Monograph Series I, Washington 1989, p. 67.
Stained Glass Before 1700 in American Collections: New England and New York (Corpus Vitrearum Checklist I), edited by Madeline H. Caviness and Jane Hayward, *Studies in the History of Art*, vol. 15, Washington 1985, p. 191.
Livelier than Life: The Master of the Amsterdam Cabinet or the Housebook Master, ca. 1470–1500, Exhibition held at the Rijksmuseum Amsterdam, edited by Jan Piet Filedt Kok et. al., 1985, nos 136b and 136c.
J.B. Rietstap, *Armorial général précédé d'un dictionnaire des termes du blason*, second edition, Gouda 1884–87, 2 vols, reprinted London 1965, vol. I, p. 588.

James Normile, 'The William Randolf Hearst Collection of Stained and Painted Glass', in *Stained Glass*, 41, 1946, pp. 39–44.

33. Heraldic Roundel with the Arms of Rummel von Lichtenau
Southern Germany, Nuremberg?
c. 1510–30
diameter: 213 mm
Inv. no. 3324

Clear glass with silver stain and black paint, red and white enamel; back painting.

ARMS Quarterly; 1st and 4th or two addorsed cocks sable (Rummel); 2nd and 3rd in chief sable, a lion passant or, and in base a barry wavy of five gules and argent (unidentified).
CRESTS [Left] On a tilting helm to sinister a coronet or, a cock proper; mantling of the colours. [Right] On a tilting helm to dexter a demi-lion rampant proper, mantling of the colours. The achievement is displayed against a damasked and bordured field.

LITERATURE
Johann Siebmacher, *Die Wappen des bayerischen Adels,* reprinted Neustadt/Aisch 1971, *Abgestorbene Bayerische Geschlechter*, I, p. 122.

34. The Arrest of Christ
North Netherlands
After the Master of the Death of Absolom
c. 1500–1510
diameter: 274 mm
Inv. no. 7058

Clear glass with silver stain, stipple shading and washes in a pinkish brown paint, back painting; set in a modern red border.

Christ (depicted without a halo) is dragged by a group of men who stand around in threatening poses. Two further men have already gone through the gate in the background; one, with yellow hair, looks back at the scene.

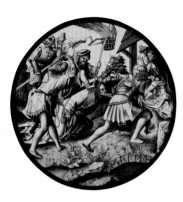

LITERATURE

Pieter C. Ritsema van Eck, *Gebrandschilderde ruitjes uit de Nederlanden, Painted glass roundels from the Netherlands, 1480–1560*, Zwolle 1999, p. 14, no. 4.
Timothy B. Husband, *The Luminous Image: Painted Glass Roundels in the Lowlands 1480–1560*, New York 1995, pp. 73–75, no. 20.
Walter S. Gibson, *Hieronymus Bosch*, London 1973, p. 64.

35. St Fiacre and a Benedictine Abbot Saint with a Donor
France, Lorraine
c. 1510–15
1278 × 406 mm; 1267 × 402 mm
Inv. no. 8356

Clear glass and red and blue pot-metal with black paint and silver stain, picked-out highlights.

St Fiacre dressed in a belted tunic (from which hangs a stylus) and a hood, holding a book and a spade. A Benedictine Abbot in a black habit. The donor, dressed in a fur-lined robe and bear-paw shoes, kneels before the Benedictine abbot. The two saints stand on tiled floors in front of rich wall-hangings (St Fiacre before a sky blue damask cloth of honour, the sainted Abbot before one of deep red). Their heads are framed by scalloped niches in the wall behind, and they wear haloes of red and yellow respectively.

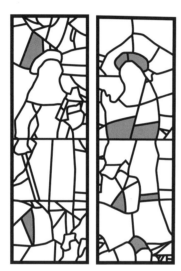

LITERATURE

Michel Hérold and Françoise Gatouillat, *Les Vitraux de Lorraine et d'Alsace, Corpus Vitrearum, France*, Paris 1994, p. 75.
Martine Callias-Bey, Véronique Chaussé, Laurence de Finance, et al., *Les Vitraux de Bourgogne, Franche-Comté et Rhône-Alpes, Corpus Vitrearum. Série complémentaire, Recensement des vitraux anciens de la France*, vol. III, Paris 1986, p. 224, pl. XI.

36. St Dorothy
France, Burgundy
after 1510–20
1287 × 561 mm
Inv. no. 8355

Clear glass with silver stain, brown, blue and red pot-metal with black paint.

St Dorothy stands holding her attributes of a basket of flowers and a martyr's palm

in an elaborate architectural niche with a tiled floor in front of a blue cloth of honour with gold fleurs-de-lis. She is flanked by decorated classical columns, and the spandrels of the arch above her head are decorated with a relief showing two mischievous putti pulling the tails of two dragons.

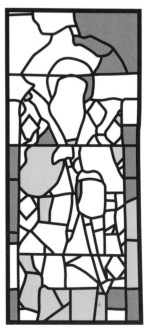

LITERATURE

Martine Callias-Bey, Véronique Chaussé, Laurence de Finance, et al., *Les Vitraux de Bourgogne, Franche-Comté et Rhône-Alpes, Corpus Vitrearum. Série complémentaire, Recensement des vitraux anciens de la France*, vol. III, Paris 1986, pp. 79–83, figs 60–62.

Willi Kurth, *The Complete Woodcuts of Albrecht Dürer*, introduction by Campbell Dodgson, New York 1963, no. 264.

37. Head of an Angel from the Last Judgement
England, St Mary's Fairford (Gloucestershire)
c. 1510–17
170 × 155 mm
Inv. no. 6946-1

Clear glass with silver staining, brown paint, stipple shading, light back painting; some scratch marks (including glazier's sorting mark '28L/e'); set in modern white glass panel.

The head comes from the West Window of the church.

PROVENANCE
1 Collection of N.H.J. Westlake.
2 Collection of Keith Barley.

LITERATURE

Keith Barley, 'Conservation and Restoration', in *Life, Death and Art: The Medieval Stained Glass of Fairford Parish Church*, edited by Sarah Brown and Lindsay MacDonald, Stroud 1997, p. 122.
Hilary Wayment, *The Stained Glass of the Church of St Mary, Fairford, Gloucestershire*, London 1984, pp. 55–8.

Hilary Wayment, 'The glaziers sorting marks at Fairford', in *Crown in Glory: A Celebration of Craftsmanship – Studies in Stained Glass*, edited by Peter Moore, Norwich 1982.

Hilary Wayment, '"Echo Answers Where": The Victorian restoration of the Great West Window at Fairford', in *Journal of the British Society of Glass Painters*, XVII, 1980–81, pp. 18–25.

38. Armorial panel of the Mollenberg(?) family of Bavaria

Switzerland, Zurich?

c. 1510–15

412 × 306 mm

Inv. no. 7556

Blue, red and purple flashed pot-metal glass, clear glass with silver stain and white and red enamel, black paint, stipple shading and back painting; top right spandrel is a modern replacement.

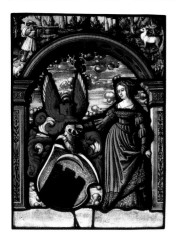

The armorial is displayed under a red-purple coffered arch supported by pilasters with Renaissance detailing. It is held by a fashionably dressed woman in a blue-purple gown with puffed sleeves, set against a blue cloudy sky. In the spandrels, a huntsman shoots at a deer.

LITERATURE

Painting on Light: Drawings and Stained Glass in the Age of Dürer and Holbein, edited by Barbara Butts and Lee Hendrix with Scott C. Wolf, Los Angeles 2000, p. 292, nos 131 and 143.
Berhard Anderes and Peter Hoegger, *Die Glasgemälde im Kloster Wettingen*, 2nd edition, Baden 1988, p. 238 and pp. 278–9.

39. The Arrest of Christ, the Flagellation and the Way of the Cross

North Netherlands

c. 1510–20

each 590 × 508 mm

Inv. no. 5512

Clear glass with black paint, silver stain, stipple shading and back painting. Set in a border of modern red glass.

1. The Arrest of Christ

Christ, identified by his yellow nimbus, is approached by Judas, whose money bag is also picked out in yellow. In the foreground, Malchus is sprawled on the ground clutching his ear which has been cut off by St Peter, who holds a sword.

2. The Flagellation of Christ

Christ is tied to a pillar in the centre of a cell while two men strike him with a whip and a birch. They are shown in fictive Roman dress, the one on the left with a helm picked out in yellow and yellow stockings and the one on the right with a sword picked out in yellow and

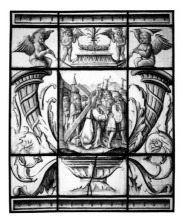

3. The Way of the Cross

The procession moves out of the city gate as Christ stumbles carrying the cross. Two crosses stand waiting in the background as he is led by a man in a white helm and a halbadier in a helm picked out in yellow, who is followed by a yellow-haired man with a spear. A turbaned man follows behind, carrying a stick, followed by a man in a hat – also carrying a stick – with another soldier in the background.

The outer two panels are set within borders of confronted acanthus leaves and cornucopia, with two haloed putti playing trumpets confronting a further two putti holding up swags in the centre. The inner panel has griffins confronting a baldacchino.

LITERATURE

Pieter C. Ritsema van Eck, *Gebrandschilderde ruitjes uit de Nederlanden, Painted glass roundels from the Netherlands, 1480–1560*, Zwolle 1999, p. 64, no. 24.
Timothy B. Husband, *The Luminous Image: Painted Glass Roundels in the Lowlands 1480–1560*, New York 1995, pp. 73–75, nos 19–20 and p. 176, no. 97.

40. St George with the Arms of Speth

Germany, Zurich?

dated 1517

543 × 464 mm

Inv. no. 5855

Pot-metal, clear glass with silver stain and enamel, flashed and abraded red and blue; triple crack to face and halo of St George.

Set within an architectural frame with the date 1517 inscribed in the centre.

On the left, looking to his right, stands the haloed St George on grass in full armour. He has one hand on his scabbard, the other holding the red cross flag, and a dragon is curled at his feet. He wears full plate armour, with an articulated gorget, spaulders, vambraces and rerebraces joined by couters at the elbow. His torso is covered by a breastplate from which hangs an elaborate fauld which parts over a mail cod-piece. The legs are protected by cuisses and greaves joined by poleyns (with fan plates, as with the elbow cops), with sabatons over the feet. Tied around the waist is a hefty two-handed sword. Not only are the individual items of armour depicted but the individual lames that articulate the whole, and even the attaching rivets, are also shown.

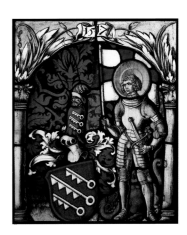

ARMS Gules three snares bendwise sinister argent (Speth).
CREST Over a barred helm to dexter a demi-man of the colours bearing the charge on his breast and hat.

PROVENANCE

Collection of Sybille Kummer-Rothenhausen, Zurich.

LITERATURE

Stained Glass Before 1700 in American Collections: Midwestern and Western States (Corpus Vitrearum Checklist III), edited by Michael W. Cothren, *Studies in the History of Art*, vol. 28, Monograph Series I, Washington 1989, p. 98 and p. 100.
Jenny Schneider, *Glasgemälde. Katalog der Sammlung des schweizerischem Landsmuseum*, 2 vols, Zurich, 1970, vol. 1, p. 61, no. 138 and p. 60, no. 135.

41. Heraldic Panels with the Arms and Crest of the Duke of Suffolk

England, East Anglia?

c. 1520

diameter: c. 430 mm

Inv. no. 7307

Arms: Pot-metal and clear glass with red and white enamel; some paint loss, especially from the crown; some pitting; modern border of clear glass.
Crest: Clear glass with silver-stain with black paint; stipple shading; considerable pitting; modern border of clear glass.

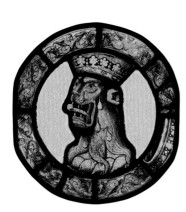

ARMS Within a garter badge of dark blue edged in gold bearing the motto *honi soit qui mal y pense* in gothic lettering, with a gold buckle and gold rosettes. Quarterly 1st and 4th a barry of ten argent and gules, a lion rampant or ducally crowned or (Brandon); 2nd and 3rd quarterly, 1st and 4th azure, a cross moline or, 2nd and 3rd lozengy ermine and gules (Broune).

CREST Within a decorative band of winged cherubs and conjoined volutes: a lion's head erased or guttée de larme argent ducally crowned argent.

PROVENANCE

1 Poughley Priory, Newbury, Berkshire.
2 The Prior's Court, Chievely, Berkshire, from the nineteenth century, until they were sold at Sotheby's in 1974. Other pieces from Poughley Priory were acquired by King's College Cambridge after the sale.
3 Collection of Christopher Gibbs, Clifton Hampden, Oxfordshire.

LITERATURE

Christie's sale, *The Manor House at Clifton Hampden*, 25 and 26 September 2000, lot 151.
Dictionary of British ARMS *Medieval Ordinary*, vol. 2, edited by T. Woodcock, Janet Grant and Ian Graham, London 1996, p. 237.
Michel Pastoureau, *Traité d'Héraldique*, second edition, Paris 1993, fig. 335.
Hilary Wayment, *King's College Chapel Cambridge: The Side-Chapel Glass*, Cambridge 1988, pp. 27 and 122.
British Heraldry from its origins to c. 1800, compiled and edited by Richard Marks and Ann Payne, exhibition held at the British Museum, 1978, London 1978, pp. 46–47, cat. 72.
Sotheby's sale, *Medieval, Renaissance and Later Works of Art*, London, 1 July 1974, lots 122 and 123.

42. A Premonstratensian Canon of Berkheim

Switzerland, Basel

Designed by Hans Holbein the Younger

c. 1520

610 × 520 mm

Inv. no. 6102

Pot-metal (blue and brown) and clear glass with black paint and silver stain (rendered green when painted behind the background), light washes for the shading and picking out of the paint for shadows and textures; a number of leaded breaks but otherwise in excellent condition.

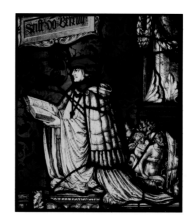

The donor kneels on a small arcaded plinth before a blue damask cloth of honour. He is dressed in the robes of a Premonstratensian canon, including pleated surplice and fur cape. He wears a cap over his short yellow hair and holds an open book with the letter H in a humanistic hand clearly visible. The book's yellow deerskin chemise hangs down between his hands. Above him on a foreshortened *tabula* from which a rich green tassel hangs is the inscription: 'Stift vo[n] Ber[ch]eim' [Prebendary Canon of Berkheim] in ornate gothic black letter. Behind him, above on the right, a massive block of grisaille architectural masonry rises with swags, berries and leaves resting on a brown plinth. Immediately behind him a naked woman with yellow hair clings to the back of a balding yellow-haired sea monster holding a jawbone and a tortoiseshell-plated shield. They move forward to the right, his yellow tail trailing behind and apparently terminating in leaves. There is an ancient insert of a small naked man on a yellow leaf and an architectural border piece on the bottom left.

LITERATURE

Urs Graf. Die Zeichnungen im Kupferstichkabinett, Basel, Beschreibender Katalog der Zeichnungen, vol. 3, *Die Zeichnungen des 15. und 16. Jahrhunderts*, part 2b, edited by Christian Müller, Basel 2002, pp. 64–65, p. 257 and p. 372.
Painting on Light: Drawings and Stained Glass in the Age of Dürer and Holbein, edited by Barbara Butts and Lee Hendrix with Scott C. Wolf, Los Angeles 2000, p. 292 and nos 138 and 146–50.
Hans Holbein der Jüngeren und Ambrosius Holbein, Die Zeichnungen im Kupferstichkabinett, Basel, Beschreibender Katalog der Zeichnungen, vol. 3, *Die Zeichnungen des 15. und 16. Jahrhunderts*, part 2a, edited by Christian Müller, Basel 1996, pp. 9–13 and no. 171, pl. 54.
Oscar Bätschmann and Pascal Griener, *Hans Holbein*, Cologne and London 1997, p. 36 and pp. 40–41.
Norbert Backmund (OP), *Monasticon Praemonstratense. Id est Historia Circariarum atque Canoniarum Candidi et Canonici Ordinis Praemonstratensis*, Staubing, vol. 1, 1952, p. 79.

43. St Sebastian

Germany?

c. 1520–30

diameter: 195 mm

Inv. no. 5714-7

Clear glass with silver stain, brown paint, stipple shading and light back painting.

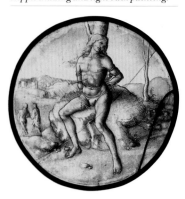

The saint is tied to the base of a tree and is pierced with four arrows: three to the chest and one to the leg. The tree stands on a hump on a rocky hill in the foreground of the composition. On the left-hand side the archers walk away from the scene towards a city in the

background. Silver-stain yellow is applied to the saint's hair and to the ropes that bind him. Touches of red are applied near the wounds.

LITERATURE

Timothy B. Husband, *The Medieval Housebook and the Art of Illustration*, New York 1999, p. 72, fig. 25.

David Landau and Peter Parshall, *The Renaissance Print, 1470–1550*, New Haven and London 1994, p. 142, fig. 147.

Timothy B. Husband, *Stained Glass before 1700 in American Collections: Silver-Stained Roundels and Unipartite Panels (Corpus Vitrearum Checklist IV)*, Baltimore 1991, p. 96.

Timothy Wilson, Patricia Collins and Hugo Blake, *Ceramic Art of the Italian Renaissance*, London 1987, p. 87, no. 135 and pl. 134.

44. Head of the bound Christ

France, Normandy?

c. 1525–30

280 × 225 mm

Inv. no 3478

Clear glass with purple and red pot metal and silver stain, painted in chestnut brown with back painting.

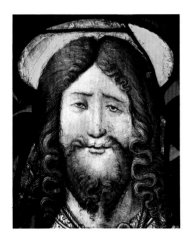

Christ wears a white shirt and has what appears to be a knotted rope around his neck.

LITERATURE

Martine Callias-Bey, Véronique Chaussé, Françoise Gatouillat, et al., *Les vitraux de Haute-Normandie, Corpus Vitrearum. Série complémentaire, recensement des vitraux anciens de la France*, vol. 6, Paris 2001.

Martine Callias-Bey, Véronique Chaussé, Laurence de Finance, et al. *Les Vitraux de Bourgogne, Franche-Comté et Rhône-Alpes, Corpus Vitrearum. Série complémentaire, Recensement des vitraux anciens de la France*, vol. III, Paris 1986, p. 23.

Nicole Blondel, Louis Grodecki, Françoise Perrot and Jean Taralon, *Les vitraux du Centre et des Pays de la Loire, Corpus Vitrearum. Série complémentaire, Recensement des vitraux anciens de la France*, vol. 2, Paris 1981, pp. 194–95, fig. 174.

45. and 46. Two Fragments from The Triumph of Chastity over Love

South Netherlands, Antwerp?

c. 1525–30

1. 260 × 160 mm

2. 355 × 125 mm

Inv. nos 4580-1, 4583-1

Clear glass with brown paint, extensive silver staining and fine stipple shading.

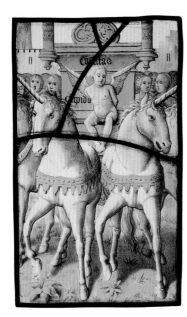

1 Four unicorns (two fully and two partly shown) draw a large, elaborate yellow chariot, inscribed 'caritas'. On the chariot sits the bound, winged cupid, his name inscribed on the left 'Cupido'. He looks down in defeat as the chariot moves forward followed by a large group of women, perhaps virgins, one crowned with flowers. The lower half of the panel with the continuation of the horses' legs is a modern replacement.

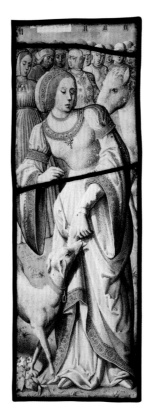

2 A woman in a long gown with embroidered cuffs stands in front of a crowd of men and women. A greyhound nuzzles her hand. The lowermost and uppermost parts are modern replacements.

LITERATURE

Timothy B. Husband, *The Luminous Image: Painted Glass Roundels in the Lowlands 1480–1560*, New York 1995, pp. 158–62, nos 81–84.

Ellen Konowitz, 'The Roundel Series of Dirick Vellert', in Timothy B. Husband, *The Luminous Image: Painted Glass Roundels in the Lowlands 1480–1560*, New York 1995, pp. 142–57, esp. p. 144, fig. 6 and p. 145, note 7.

William Cole, *A Catalogue of Netherlandish and North European Roundels in Britain, Corpus Vitrearum Medii Aevi, Great Britain, Summary Catalogue I*, Oxford 1993, nos 242, 717, etc.

George Wingfield Digby and Wendy Hefford, *Victoria and Albert Museum. The Tapestry Collection. Medieval and Renaissance*, London 1980, pp. 35–38, nos 22–24, pls 36–38.

Yvette Vanden Bemden, 'Rondels représentant les Triomphes de Pétrarque', in *Revue Belge d'Archéologie et d'Histoire de l'Art*, 46, 1977–78, Brussels 1979, pp. 5–22.

Sophie Schneelbach-Perelman, 'Un nouveau regard sur les origines et le développement de la tapisserie bruxelloise du XIVe siècle à la pré-Renaissance', in *Tapisseries bruxelloises de la pré-Renaissance, Musées Royaux d'Art et de L'Histoire*, Brussels 1976, pp. 185–89.

Jean Helbig and Yvette Vanden Bemden, *Corpus Vitrearum Medii Aevi Belgique III, Les Vitraux de la première moitié du XVIe siècle conservés en Belgique: Brabant: Limbourg, Ledeburg and Ghent 1974*, pp. 275–81.

47. Panel of quarries

England

late 15th and early 16th century

490 × 220 mm

Inv. no. 3016-2

Clear glass with silver stain and black paint; glass with bubbles and a number of blisters.

TOP CENTRE A pair of yellow silkworms(?) joined by an entwined cord; 140 × 95 mm.

MIDDLE CENTRE A crowned R monogram for Richard III (r. 1483–85); 130 × 80 mm.

BOTTOM CENTRE Crowned IHC monogram for Christ; 145 × 95 mm.

TO EITHER SIDE Four quarries with ornamental flower designs; all 150 × 100mm.

The whole ensemble is framed by half quarries of ornamental flower designs.

LITERATURE

Peter Lasko, *Glasgow Art Gallery and Museum. Stained and Painted Heraldic Glass. Burrell Collection: British and Selected Foreign Armorial Panels*, Glasgow 1962, p. 48, nos 205, 207.

John Baker, Herbert Read and Alfred Lammer, *English Stained Glass*, London 1960, p. 227 and p. 237, no. 101.

Christopher Woodforde, *English Stained and Painted Glass*, Oxford 1954, pl. 40.

Bernard Rackham, *Victoria and Albert Museum. A Guide to the Collection of Stained Glass*, London 1936, pl. 20, nos 1247–1855 and 930–1900, etc.

48. An Emperor or a King

Netherlands

c.1550

diameter: 255 mm

Inv. no. 7371

Clear glass with pink-brown wash, silver stain and black paint, stipple shading, the fine curls of the hair especially delicately painted and picked-out.

Head of a figure with a pronounced aquiline nose clad in plate armour and wearing a triangularly spiked crown. He is turned so that he is seen in profile. The face has been drawn in a black outline. The crown, edges of the breastplate and clasps are all picked out in yellow, as is the top of the chain mail under the chin.

LITERATURE

Timothy B. Husband, *The Luminous Image: Painted Glass Roundels in the Lowlands 1480–1560*, New York 1995, p. 195, nos 115–16 and nos 117–20.

William Cole, *A Catalogue of Netherlandish and North European Roundels in Britain, Corpus Vitrearum Medii Aevi, Great Britain, Summary Catalogue*, London 1993, p. 44, nos 378–81 and no. 355.

Timothy B. Husband, *Stained Glass before 1700 in American Collections: Silver-Stained Roundels and Unipartite Panels (Corpus Vitrearum Checklist IV)*, Baltimore 1991, p. 51 and pp. 220–21.

49. The Archangel Michael

South Netherlands?

c.1530

diameter: 269 mm

Inv. no. 4338

Clear glass with silver stain (ranging from lemon yellow to orange); fine stipple shading in a pinkish brown paint, picked-out highlights.

The flying figure of the Archangel Michael stands over a defeated Devil who falls down into hellfire. The figures are set against a background of a hilly and wooded landscape with houses.

LITERATURE

Pieter C. Ritsema van Eck, *Gebrandschilderde ruitjes uit de Nederlanden, Painted glass roundels from the Netherlands*, 1480–1560, Zwolle 1999, p. 80, no. 31.

Timothy B. Husband, *The Luminous Image: Painted Glass Roundels in the Lowlands 1480–1560*, New York 1995, pp. 81–85, nos 26 and 27.

Timothy B. Husband, *Stained Glass before 1700 in American Collections: Silver-Stained Roundels and Unipartite Panels (Corpus Vitrearum Checklist IV)*, Baltimore 1991, p. 123.

50. Housing the Stranger

North Netherlands

After a print by Dirck Coornhert(?) based on a design by Maerten van Heemskerck

c.1560–70

270 × 224 mm

Inv. no. 5510-7

Clear glass painted in brown wash with fine stipple shading; panel incorporates an unrelated section of three fragments from contemporary glass in the same technique on the lower right-hand side.

Two men greet and shake hands at an open doorway. The man on the left is wearing a travelling hat and bears a staff and carries a water bottle on his back. The man on the right, standing at the top of two steps, is in a cap and sandals and wears long robes covering a fur tunic. A woman with a staff and a man, both in travelling, hats approach from the background. Inside the house or hostel on the right a naked man is seen on a bed. Above, on the right and in the far distance on a balcony, a woman tends to a sick man in bed. Fragments from unrelated pieces of glass in the same style at bottom right depict a man in boots and two jugs of water. These may have come from lost panels of the same series.

LITERATURE

Timothy B. Husband, *The Luminous Image: Painted Glass Roundels in the Lowlands 1480–1560*, New York 1995, pp. 195–97, nos 115–16 and nos 117–20.

Ilja Veldman and Ger Luiten, *The New Hollstein: Dutch and Flemish Etchings, Engravings and Woodcuts 1450–1700, Maerten van Heemskerck*, part 2, Roosendaal 1994, pp. 37–43, no. 333.

William Cole, *A Catalogue of Netherlandish and North European Roundels in Britain, Corpus Vitrearum Medii Aevi, Great Britain, Summary Catalogue*, London 1993, p. 7, no. 52 and p. 61, no. 519.